Over Southeast Florida

Photographs by Charles Feil

Text by Kevin M. McCarthy

PINEAPPLE PRESS, INC.
Sarasota, Florida

ACKNOWLEDGMENTS

Thanks to the family, friends, and strangers who have unselfishly come to my aid in paving the way to the successful completion of this book. They have supported me with a place to lay my head at night, fuel for the mind and body, or hangar space for a tired *Rooty* at the end of a long day of flying. Kudos to Maralyce Ferree for her unwavering love and support of my passions and goals; to my son Dylan, whose sensitive insights keep the fire in my soul aglow; to Ken and Maria Feil for sharing their extensive knowledge of south Florida as well as their love and friendship; and to my parents, brothers, and friends, who have been avid supporters of my books and projects throughout my career. Special thanks go to James Wyatt of Wyatt Aviation in Homestead for allowing *Rooty* and me to hang our rotors and hat, respectively, at his flight base operations. Last , but not least, thanks to David and June Cussen and the staff at Pineapple Press for their belief and promotion of this unique view of southeast Florida.
—Charles Feil

Many thanks to Paul George, who helped me identify some of the sites in Chuck Feil's wonderful photographs and corrected some of my captions. I'd particularly like to acknowledge the efforts of the many Floridians in southeast Florida who are working hard to keep a careful balance between the environment and the needs of the many residents and visitors whose demands for an increasing infrastructure put great strains on that fragile environment.
—Kevin McCarthy

Inquiries should be addressed to:

Pineapple Press, Inc.
P.O. Box 3889
Sarasota, Florida 34230

www.pineapplepress.com

Library of Congress Cataloging-in-Publication Data

Feil, Charles, 1948-
 Over southeast Florida / by Charles Feil and Kevin McCarthy.
 p. cm.
 ISBN 1-56164-338-6 (alk. paper)
 1. Florida—Aerial photographs. 2. Everglades (Fla.)—Aerial photographs. 3. Miami-Dade County (Fla.)—Aerial photographs. 4. Palm Beach County (Fla.)—Aerial photographs. 5. Broward County (Fla.)—Aerial photographs. 6. Florida—History, Local. I. McCarthy, Kevin (Kevin M.) II. Title.
 F312.F45 2005
 975.9'0022'2—dc22

 2005010829

13 digit ISBN 978-1-56164-338-7

First Edition
10 9 8 7 6 5 4 3 2 1

Printed in China

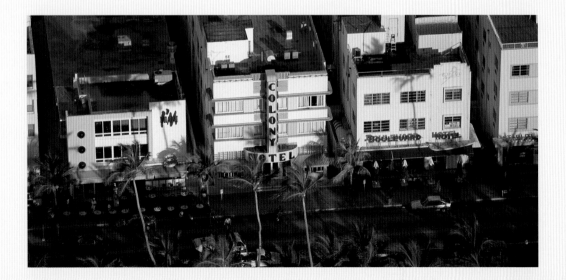

CONTENTS

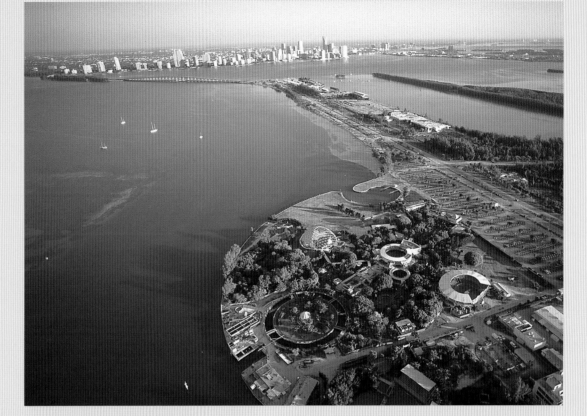

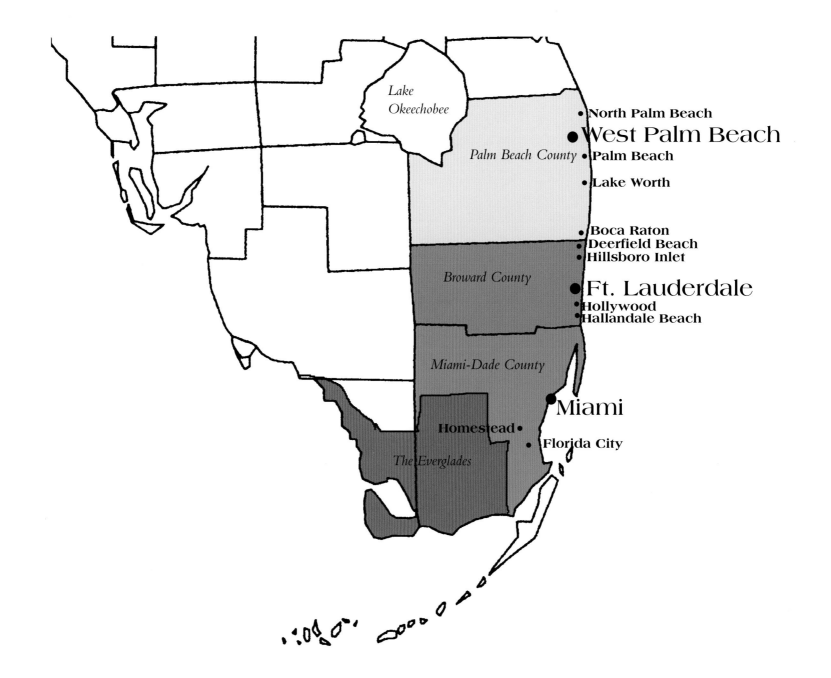

Lake
Okeechobee

North Palm Beach

West Palm Beach

Palm Beach County • Palm Beach

Lake Worth

Boca Raton

Deerfield Beach

Hillsboro Inlet

Broward County

Ft. Lauderdale

Hollywood

Hallandale Beach

Miami-Dade County

Miami

Homestead

Florida City

The Everglades

INTRODUCTION

Florida, the Sunshine State, evokes images of endless blue skies, warm waters, golden sunsets, sugar-white beaches. If you add "southeast" in front of it, your images keep the blue skies and warm waters but add urban scenes of modern skyscrapers and long rows of either Art Deco hotels or red-tile-roofed homes with dazzling swimming pools. My mind's eye fantasized these visions as I headed south on I-95 out of Portland, Maine, on a cold January afternoon, my camper securely strapped to my pickup bed, towing my RAF 2000 gyroplane named *Rooty Kazooty*. I was embarking on a new photographic journey to explore southeast Florida from the air. As the tires hummed in rhythm over the fifteen hundred miles of highway, I thought about the "snowbirds," those human winter residents who, like migrating robins, head south as the trees lose their leaves.

Of course, what I found when I arrived is that most southeast Floridians live on this warm shore year-round, many in tall condos, leading a lifestyle as urban as Manhattanites. And many have not migrated from the north like robins or snow geese, but from the south like the exotic parrots that have been blown onto the Florida peninsula by summer's hurricanes. Southeast Florida—particularly Miami, of course—moves to a Latin beat, drinks mojitos and café cubano, and speaks as much Spanish as English. From the air you somehow get a sense of the cultural muddle below: the peculiar mixture of old-time Floridians, Northern newcomers, Latin immigrants, retirees, and on-to-the-next-thing young moderns that make up southeast Florida today.

I spent a month flying and photographing Florida from my lofty perch of five hundred feet. For *Rooty* and me, it was an opportunity to explore these patchwork quilts of land that support vibrant metropolises right alongside natural wildlife habitats and vast agricultural fields. Along the way we were treated to magnificent sunrises reflecting off bay windows of beach homes and the tall glass of seaside condos. I viewed the last remains of the stilt homes in Key Biscayne and witnessed container ships and cruise ships coming and going through the narrow straits between Fisher Island and South Beach into the port of Miami. I flew over diverse communities that cling to real estate made of coral, shell, and sand. I swooped down to see protected sea and wildlife preserves that save the past for the future. I zoomed over the crowded streets of South Beach and zigzagged around tall buildings—and tall cranes building more tall buildings. I realized that no matter when I photographed this growing city, my photo essay would soon go out of date. But here it is: a month of southeast Florida captured early in the twenty-first century—in all its subtropical, frenzied beauty. Southeast Florida as seen from above reveals a tropical paradise, complete with a cultural identity—an intrinsic *golden coast* like none other. Enjoy the views! ☀

MIAMI-DADE COUNTY

Miami-Dade County is like no other place in the United States, not only because of its ethnic and linguistic mix (American, Cuban, Haitian), but also because of its geographic location (near Hurricane Alley and the Gulf Stream) and potential for growth. Its proximity to lucrative South American markets, diverse sports ranging from horse racing and jai alai to professional baseball and football, and its maritime heritage, including pirates and shipwrecks, and refugees arriving by raft, all make Miami-Dade unique.

As a gateway to the Caribbean, it is a truly bilingual community, even trilingual in certain parts where Haitian and Cuban immigrants live side-by-side with monolingual English speakers. Although in the path of some hurricanes because of its proximity to the ocean, the county has many golden beaches dotted with deeply tanned beachgoers, Art Deco hotels, busy nightlife, homes of some of entertainment's most glamorous stars, modern art museums, as well as quiet neighborhoods away from the hustle and bustle of downtown.

The county's population is very diverse—more than half the people were born overseas. It attracts thousands of South American shoppers each year who may take in a baseball game with the Florida Marlins or a football game with either the Miami Dolphins or the University of Miami Hurricanes. It is

third in popularity among cities in the United States for international visitors, behind only Los Angeles and New York.

The county has had its image problems, going back to the days when mobster Al Capone lived there. But after the popular television show *Miami Vice* pointed out Miami's many homicide and drug problems, a vigorous campaign in the late twentieth century, partly driven by the real threat that tourists wanted to avoid the city, has curbed violence dramatically.

The city is large and keeps growing with retirees, refugees, entrepreneurs, and those wishing to enjoy the sun and surf available along the many beaches. Miami-Dade County is the size of Rhode Island and has the problems of major urban areas, but it also has a vibrancy, a beat with a Latin flavor, an attraction that keeps growing.

Despite its huge size, which continues to increase as more and more people move to the city, Miami traces its modern growth to the relatively recent year of 1896. In that year, Henry Flagler extended his railroad down the east coast of Florida to Miami. Before then, very few settlers lived there. After that date, a constant stream of workers, entrepreneurs, and refugees, almost all of whom had families, settled down and added to the metropolis that is so vibrant today. ☀

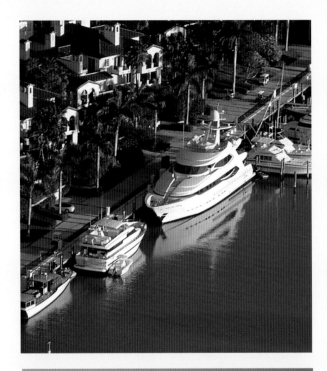

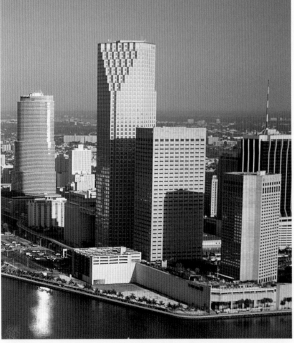

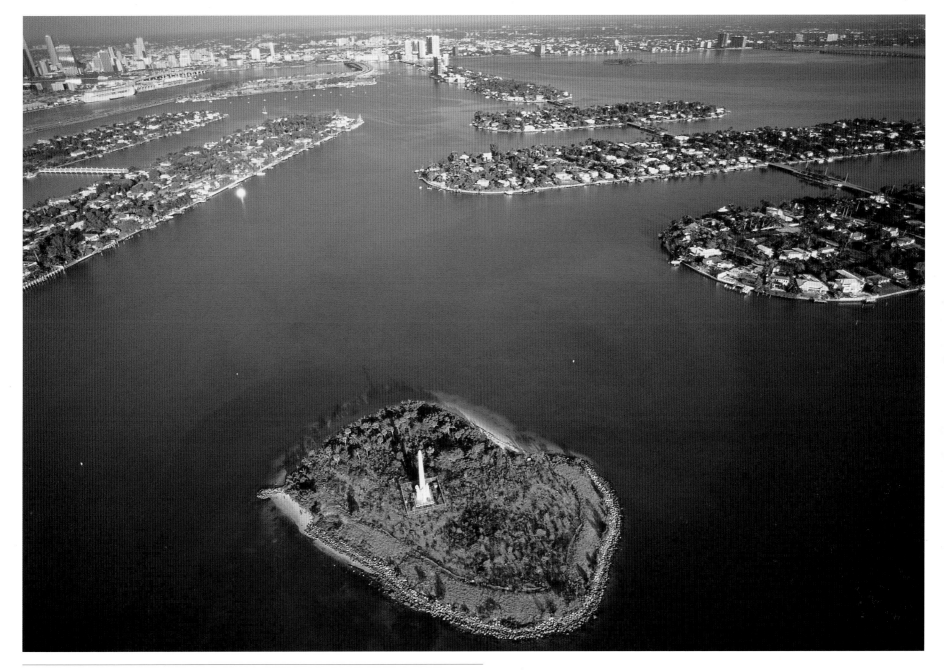

Flagler Memorial Island in Biscayne Bay, below the Venetian Causeway, has an obelisk that honors the most important person in the development of south Florida: Henry Flagler. In 1896, the same year that the City of Miami was incorporated, Flagler built a railroad to Miami after a hard freeze destroyed much of the citrus industry in north Florida. He would later extend the railroad to Key West and begin the ongoing development of south Florida. The island is accessible only by boat.

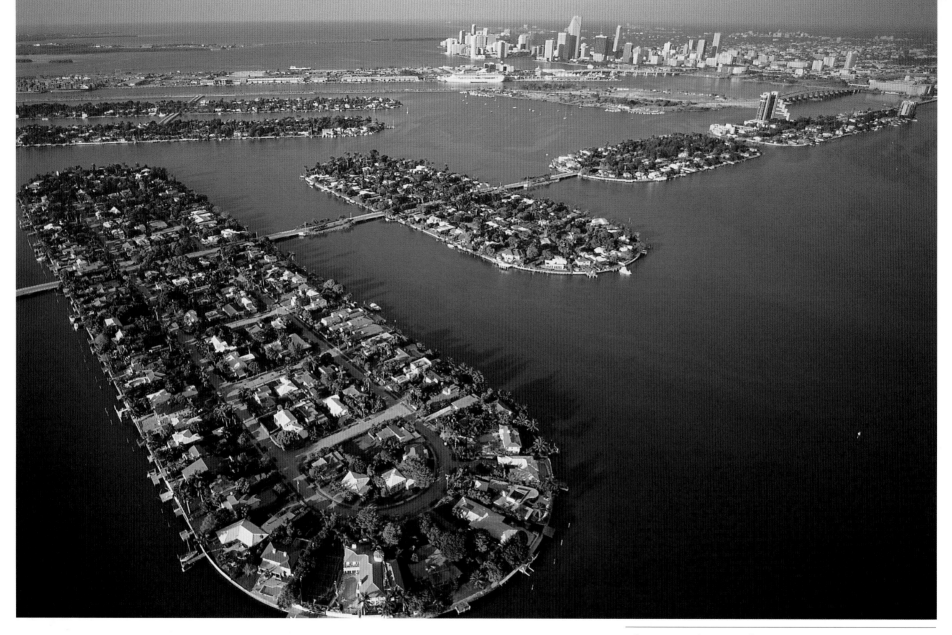

The expensive homes on the Venetian Islands in Biscayne Bay are near the Venetian Causeway, which dates back to 1925. The islands, advertised as "Gems of America's Mediterranean," are man-made and have such names as Rivo Alto, DiLido, San Marino, San Marco, and Biscayne, as well as one natural island, Belle Isle. Developers had planned on building another six similar islands in Biscayne Bay, but the real estate bust of the 1920s ended that project.

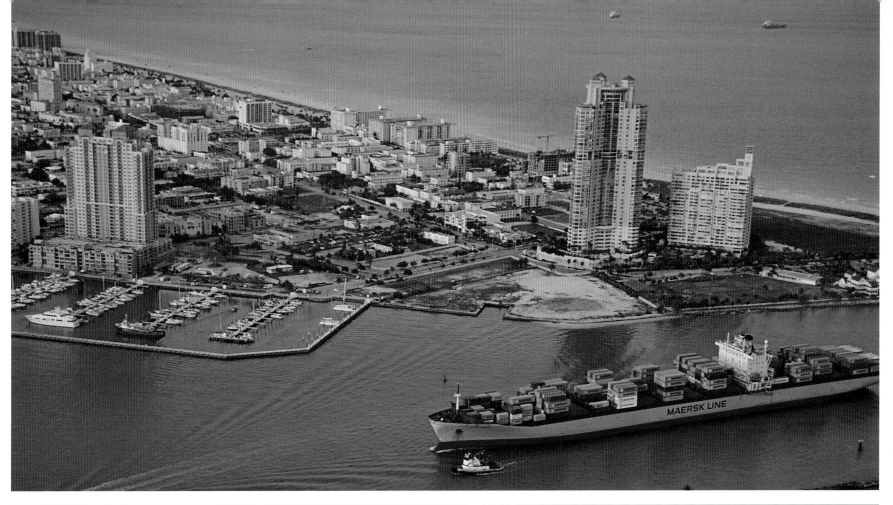

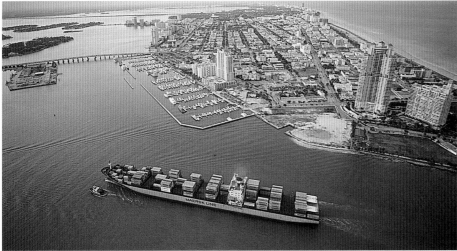

A container ship belonging to Maersk shipping line comes into Government Cut, a man-made channel built at the beginning of the twentieth century to make Miami more accessible to big ships. In dredging the cut, engineers cut away the southern tip of Miami Beach to make Fisher Island, which is south of the channel. Only about a hundred years old, the Port of Miami is the world's busiest cruise port. Each week several thousand passengers board large cruise ships there, and the cruise industry pours over two billion dollars into south Florida's economy each year.

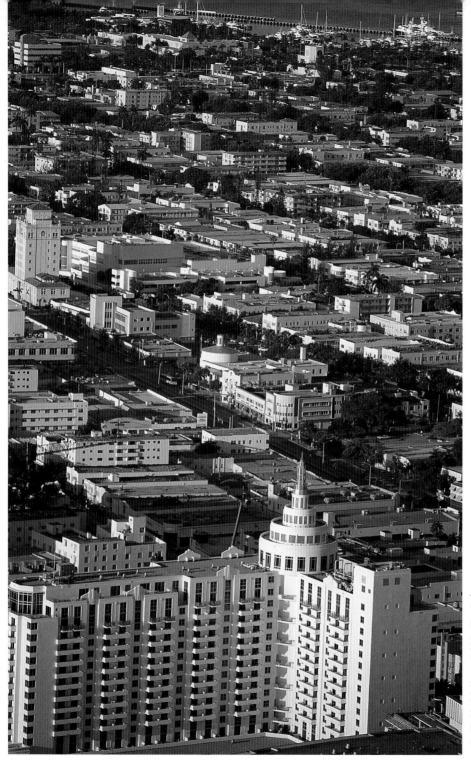

The southern part of Miami Beach, known as South Beach, is famous for its Art Deco and colorful buildings in a rainbow of pastel shades. The placement of approximately one thousand of these buildings on the National Register of Historic Places in 1979 protected the buildings from being torn down to make way for more high-rises. The small buildings in the one-square-mile district have revived what had been a derelict area, but is now full of trendy restaurants and chic bistros. The tall building in the foreground is Loews Hotel, which opened in 1998 and has over eight hundred rooms.

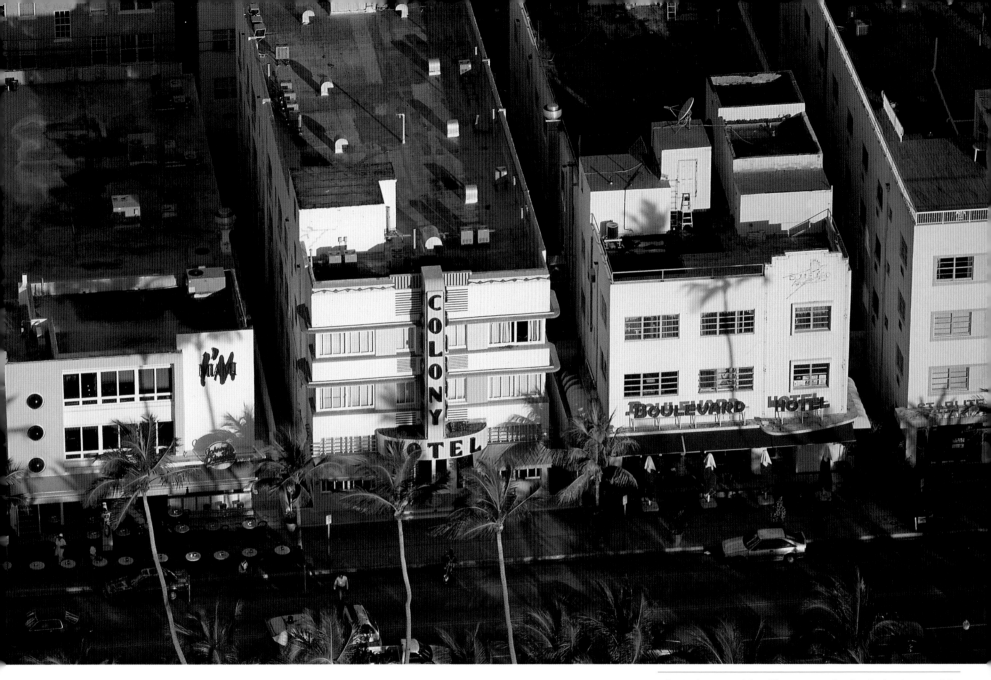

The Colony Hotel has fifty rooms and a façade that is one of the most recognizable on South Beach, while the Boulevard Hotel has thirty-five rooms and access to the beach and Lummus Park across the street.

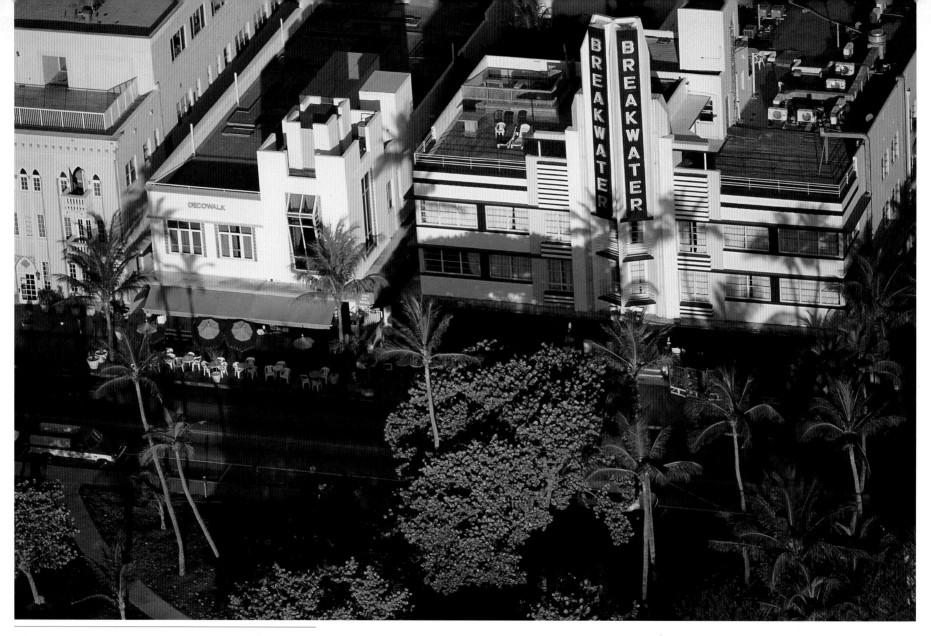

The Breakwater Hotel was originally built in 1939 and is considered one of the jewels on Ocean Drive in the heart of the historic Art Deco District of Miami Beach. It has a combination of American liveliness and European style. The building to the left of the Breakwater is the Deco Walk Hotel, a popular hotel for visiting dignitaries from around the world.

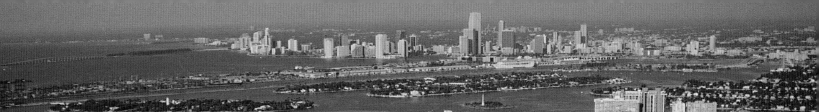

The South Beach Art Deco District had a renaissance in the 1990s as movie stars and other entertainers made it a tropical playground for the rich and famous.

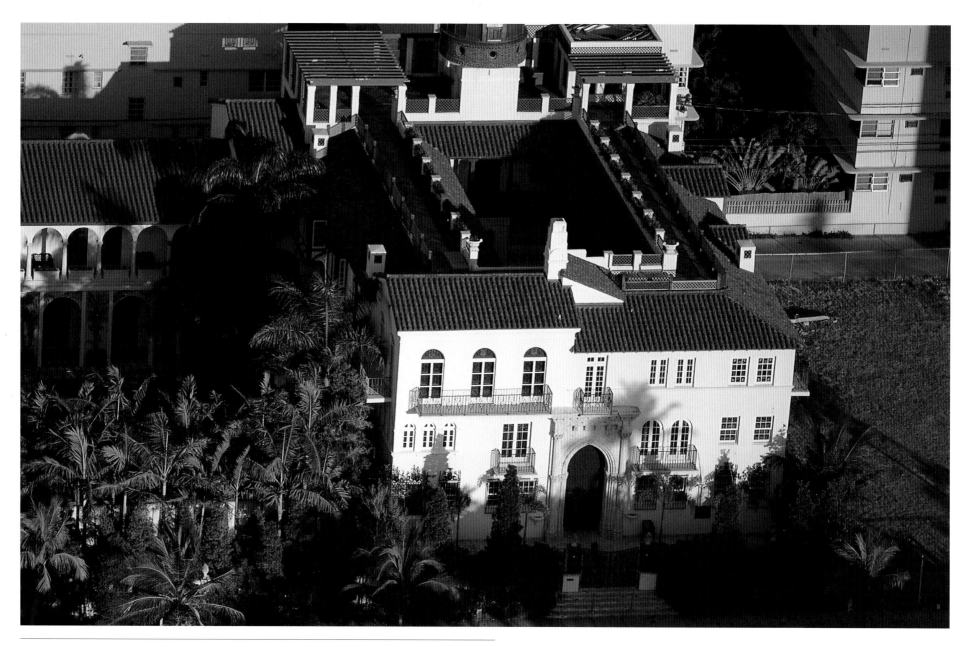

This beautiful mansion, Casa Casaurina, is the former home of the late Gianni Versace. Built in 1930, it was known as the Amsterdam Palace until he took it over in the early 1990s. In July 1997, he was murdered on the entry steps by a man who later committed suicide. The mansion is now a luxurious special event and catering venue.

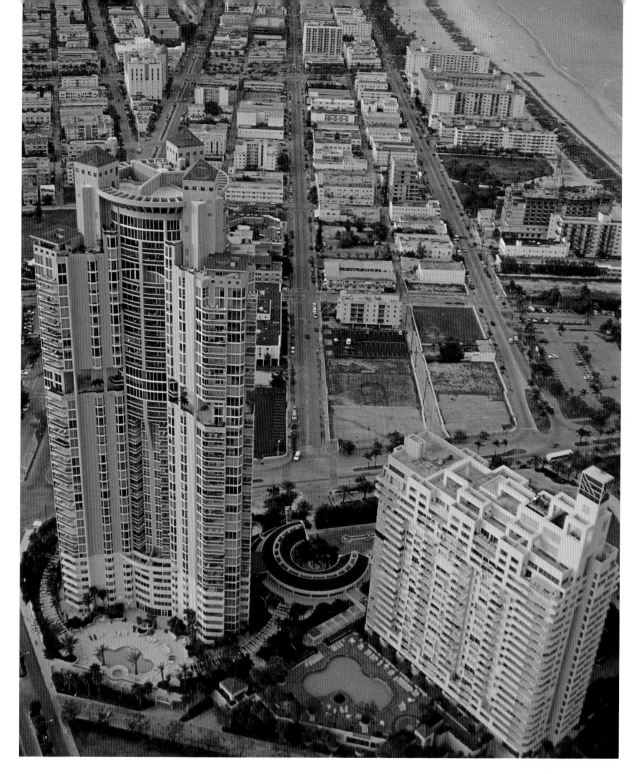

The tall building on the left is the Portofino Towers, which were finished in 1997. Biscayne Street goes from east to west, and Washington Avenue goes from north to south. The floor-to-ceiling windows in this 44-story building offer spectacular views of the ocean and the City of Miami.

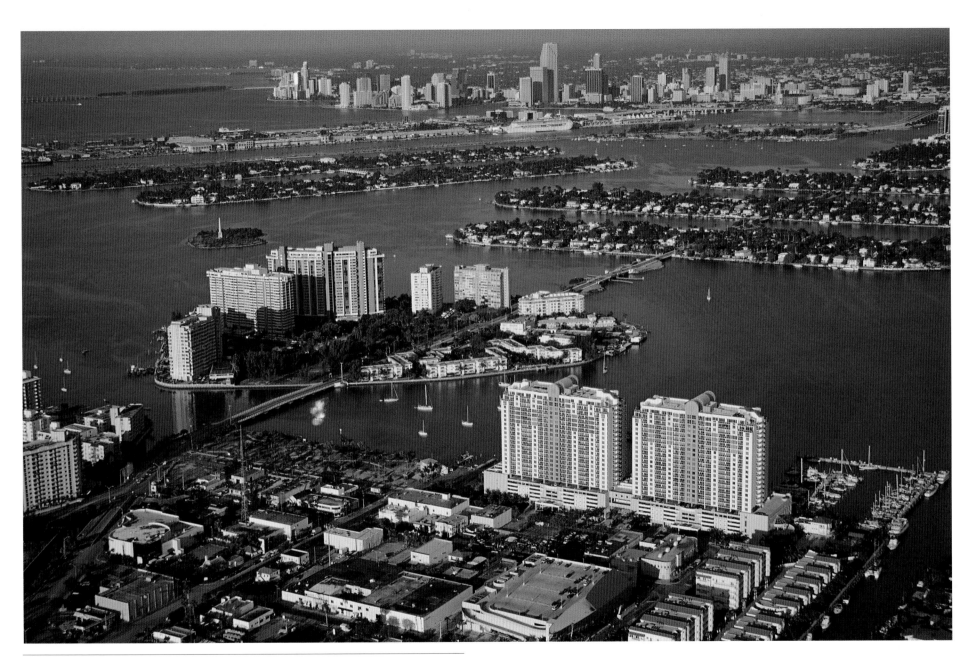

The Venetian Causeway connects Belle Island—in the foreground with the tall condominiums—with the Venetian Islands in the distance. The first three islands beyond Belle Island are Rivo Alto Island, Dilido Island, and San Marino Island. Eleven small, uninhabited islands near the Venetian Causeway were surrounded in 1983 by pink woven polypropylene fabric designed by Christo and Jeanne-Claude.

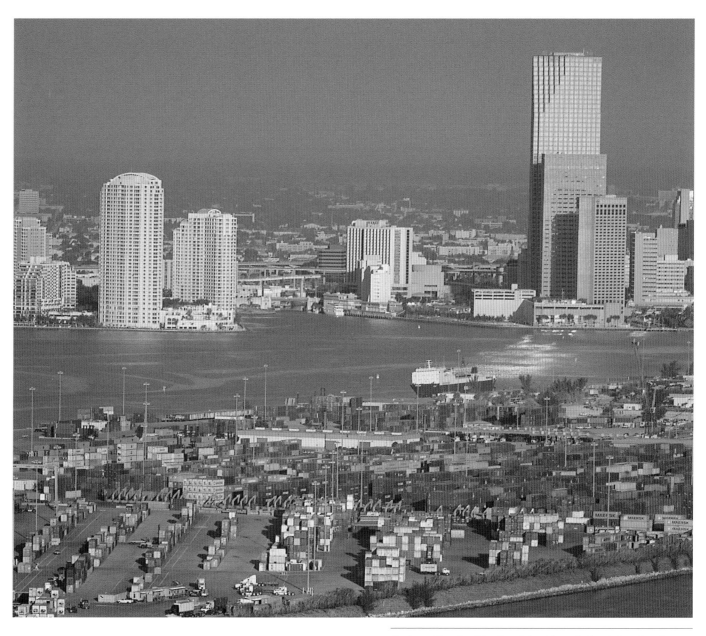

A view of Dodge Island and the City of Miami from South Beach. The tall white building on the left in the background is near Tequesta Point on Claughton Island. The taller white building on the right is Wachovia Tower. The shorter building in front of that one is Miami Center. The shorter brown building in front of that one is the Intercontinental Hotel.

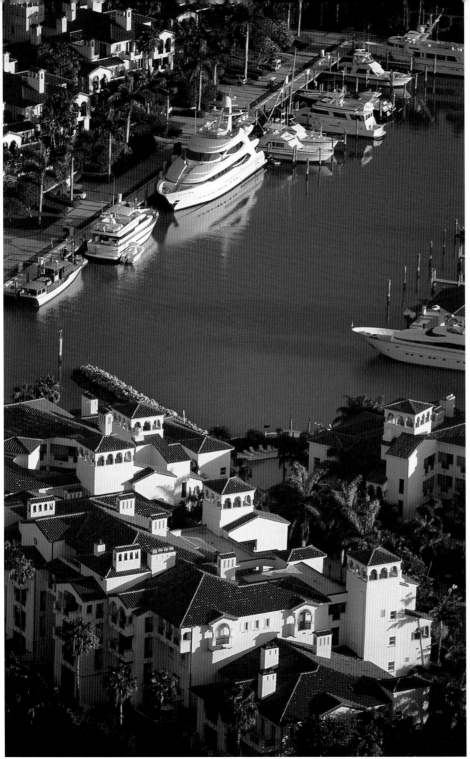

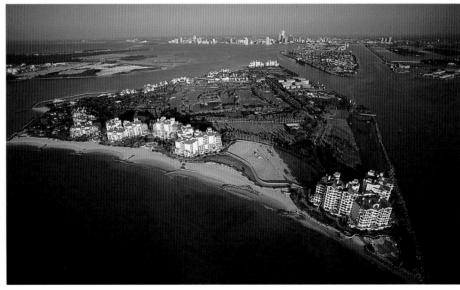

Miami Beach's major developer, Carl Fisher, bought this island, which now bears his name, but later traded it to one of the Vanderbilts for a 250-foot yacht and its crew. Vanderbilt then built a Spanish Mediterranean–style mansion, guest houses, studios, tennis courts, and a golf course there. Today, the island is accessible only by boat and air. The condominiums near the mile-long private beach, with its white sand imported from the Bahamas, cost between one million and seven million dollars. This island was the wealthiest per capita in the United States, according to the 2000 census.

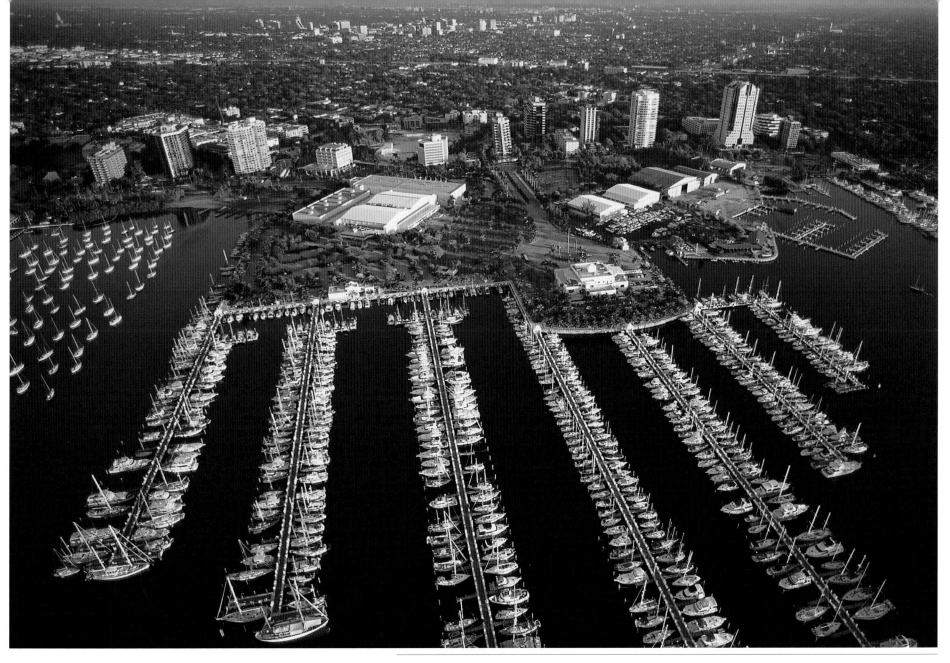

Dinner Key Yacht Club, which is south of Miami in Coconut Grove, has a name that goes back to the early days when visitors would picnic there. In the 1930s, Pan American Airways made Dinner Key the busiest seaplane base in the country. The marina, Miami's largest, has 575 moorings. Aviator Charles Lindbergh used to fly out of Dinner Key as he surveyed new routes for Pan Am in the Caribbean and South America. President Franklin Roosevelt flew out of Dinner Key in 1943 on his trip to meet Winston Churchill and Joseph Stalin in Casablanca to plan Allied strategy for the rest of World War II. That flight made Roosevelt the first president to travel by airplane while in office.

19

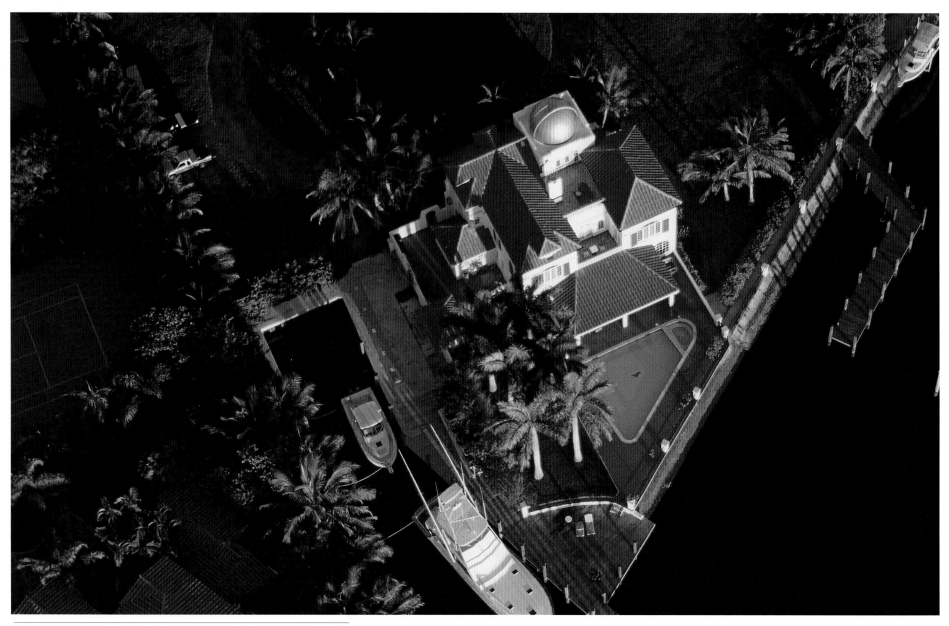

Today Coconut Grove has many multimillion dollar homes, like the one shown here, in addition to the preserved early cottages. In the early days of Miami, the population of the Coconut Grove area included Bahamians, Key Westers, and New Englanders, all of whom wanted to live in a beautiful place with growing opportunities.

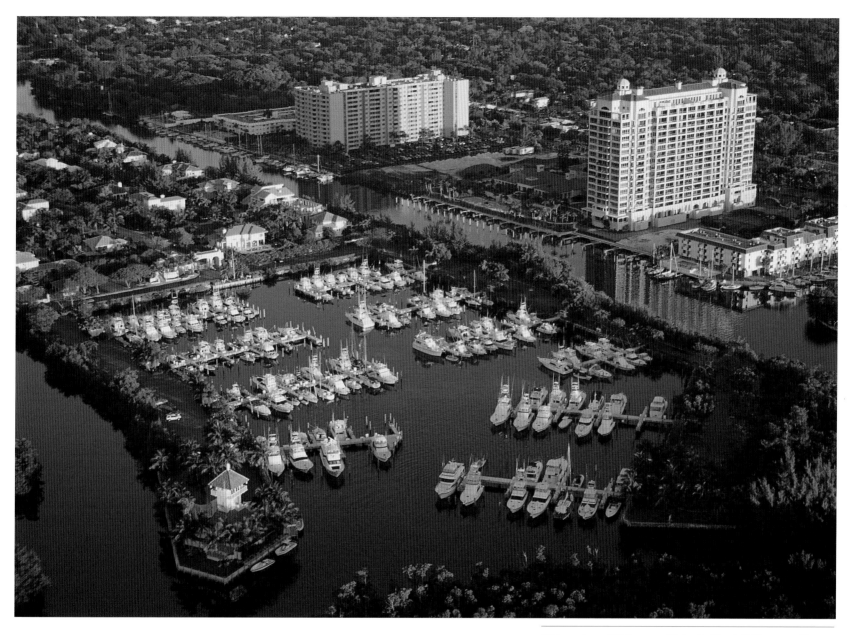

This section off Edgewater Drive in Coral Gables, near Coconut Grove, is replete with condominiums and yachts. Miami-Dade County has over 54,000 registered boats of all sizes and makes.

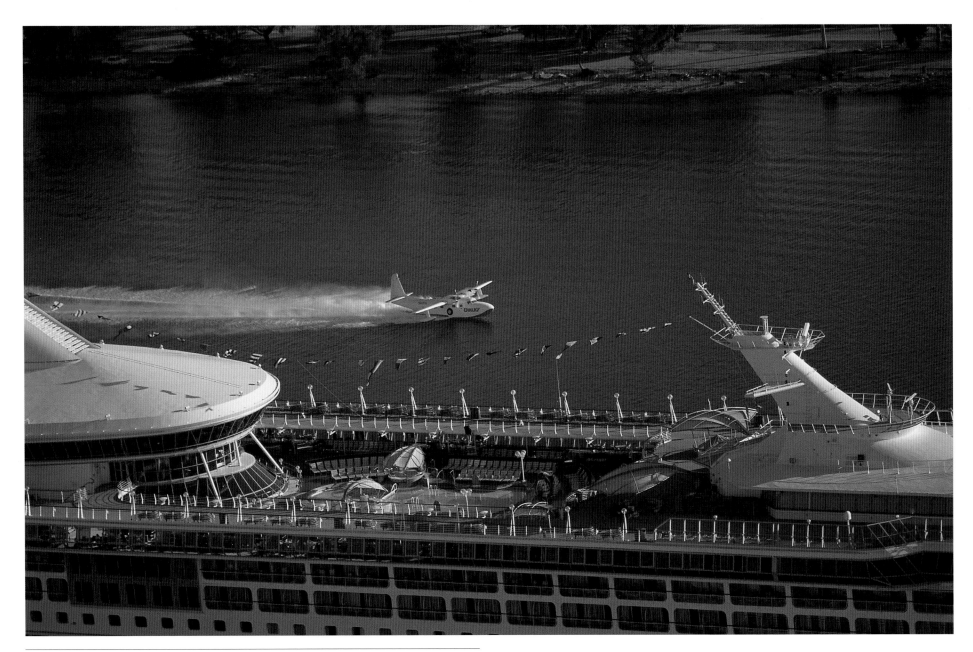

The Miami harbor caters to seaplanes and cruise ships these days. The seaplane that is taking off in the channel between Watson Island and Dodge Island is part of Chalk's Ocean Airways, an airline founded by Arthur Burns "Pappy" Chalk in 1919, and originally called Chalk's Flying Service. It specialized in flying Grumman amphibious planes between Miami and the Bahamas, and carried customs agents, bootleggers, and their customers during Prohibition, as well as fishermen to the Bahamas and tourists to the Florida Keys.

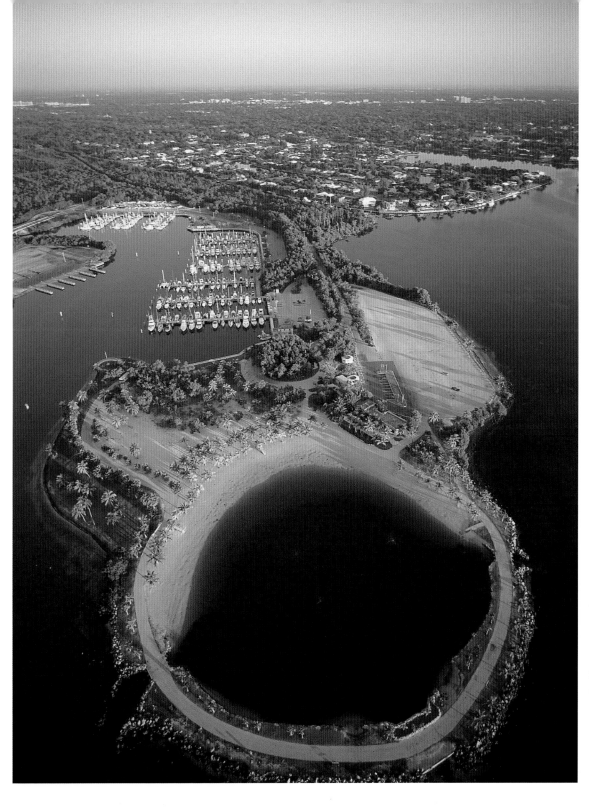

Matheson Hammock Park and Marina in Coral Gables is known for its sandy beach and atoll pool. Commodore J. W. Matheson donated the land for a park, and the Civilian Conservation Corps built it at the end of the 1930s. It featured a salt-water swimming pool surrounded by sand and palm trees next to Biscayne Bay. Hurricane Andrew damaged the park in 1992, but it has since been repaired.

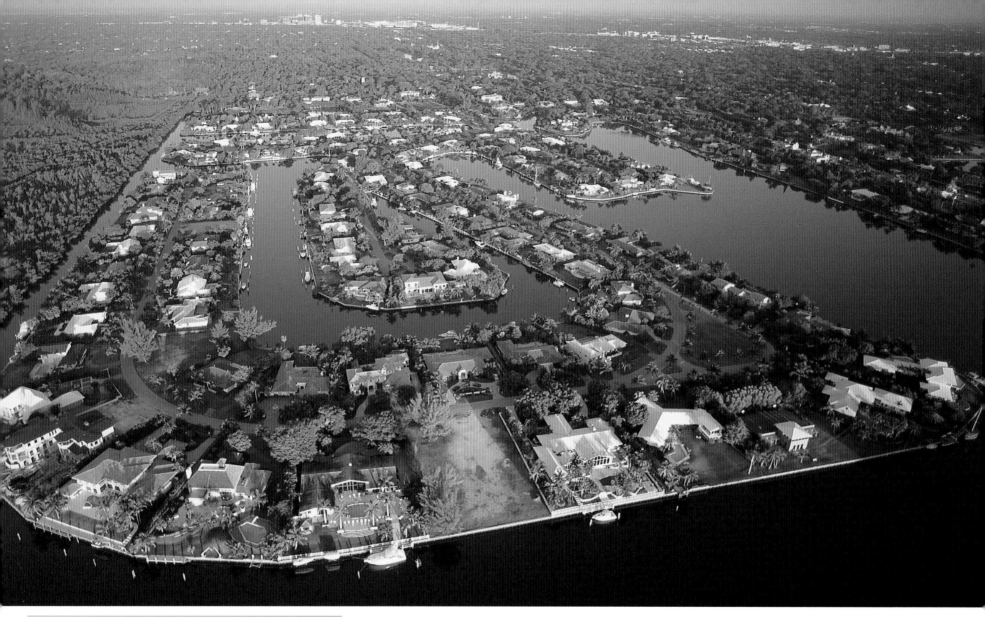

Coral Gables home sites near Matheson Hammock Park are part of
an area that developer George Merrick built in the 1920s. By 1926,
he owned or controlled about ten thousand acres in the area. He
took 1600 acres of his own land, bought another 1400 acres, and
then designed a model suburb, which now includes the University of
Miami. All of this idyllic setting seems far away from the hustle and
bustle of the City of Miami.

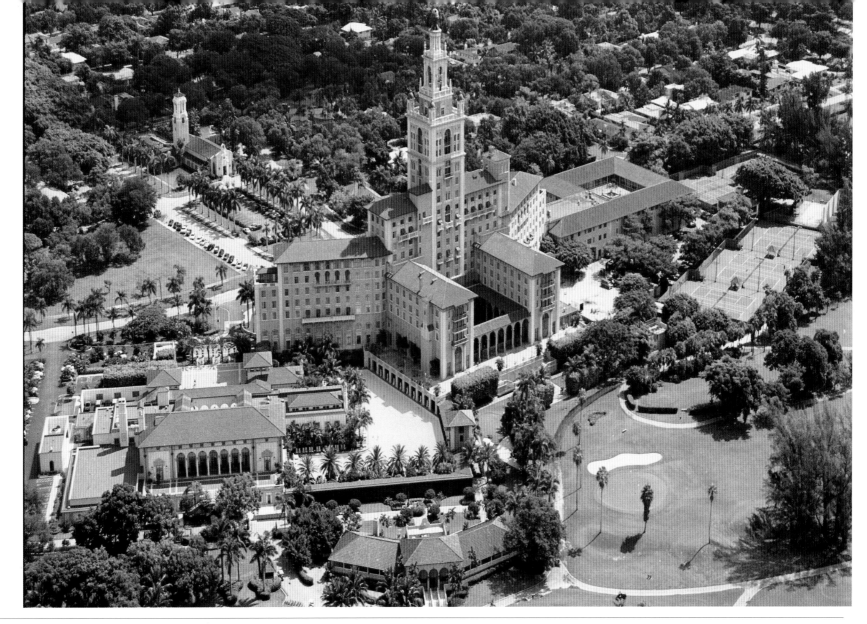

The Biltmore Hotel in Coral Gables, built by George Merrick and John McEntee Bowman, opened in 1926. Over the years The Biltmore has had many famous guests, including the Duke and Duchess of Windsor, Ginger Rogers, Judy Garland, Bing Crosby, and Al Capone. The hotel served as the Army Air Force Regional Hospital during World War II, and later as an early site of the University of Miami School of Medicine; it was also a VA hospital until 1968. In 1973 the City of Coral Gables was granted ownership control of the Biltmore, but it remained unoccupied for about ten more years; it was finally restored to its former glory as a grand hotel, a process that began in 1983, and it reopened in 1987. The Seaway Hotels Corporation took over the hotel in 1992 and it again underwent extensive renovations. In 1996 the hotel celebrated its 70th anniversary, and the federal government designated it a National Historic Landmark.

Merrick designed the original Coral Gables according to a Mediterranean-revival motif. He would not allow identical houses to be built, required all designs to be approved by the official city architect, and built a waterway connecting it to Biscayne Bay. The great real estate boom collapsed in 1926, bringing the development to a halt, but the city still retains an architectural charm that manifests itself in colorful houses and strict parking rules that keep out unseemly trucks.

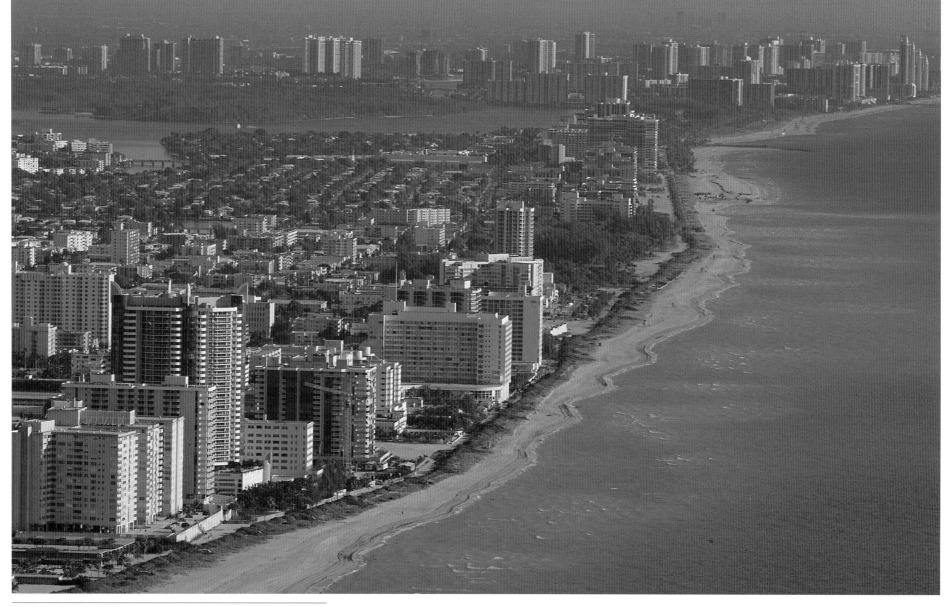

Bakers Haulover Beach County Park, in the foreground of the photograph, is located just north of Bal Harbour and is a clothing-optional beach with government-erected signs alerting visitors to the nude beach's boundaries. On its half-mile-long beach, there will be a thousand or more weekend visitors getting their all-over tans and playing volleyball in the nude. Oleta River State Park, in the background, is the largest urban park in Florida. It is located on Biscayne Bay and features the Oleta River. One can see water birds along the mangrove-lined shoreline, and even an occasional manatee.

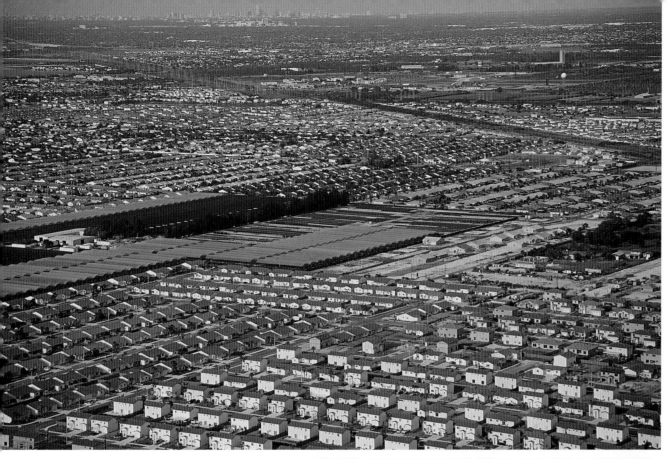

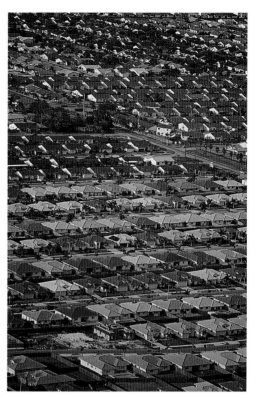

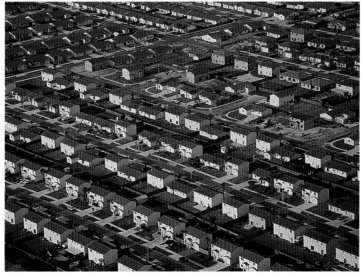

The many look-alike houses in South Miami Heights, between Cutler and Homestead, were inexpensive to mass-produce and allowed many families to buy their first homes. In 2000, over thirty-three thousand people lived in the community, which is only about five square miles in size. Over half the population there is Hispanic.

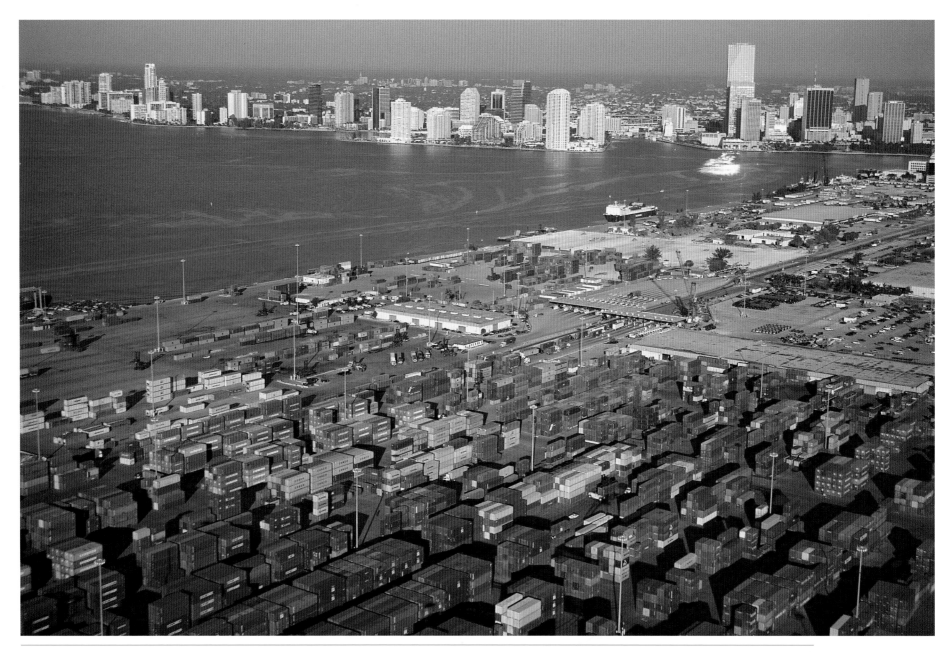

Shipping containers on Dodge Island, east of downtown Miami, show how busy the Port of Miami can be. The original port in downtown Miami was replaced by this modern port in 1964, named the Dante Fascell Port of Miami after a powerful Congressman who convinced Congress to help fund the construction of the port. Today, more than three million passengers board ships there each year, and fifty cargo lines use it. The south side of the port is the tenth busiest container port in the United States.

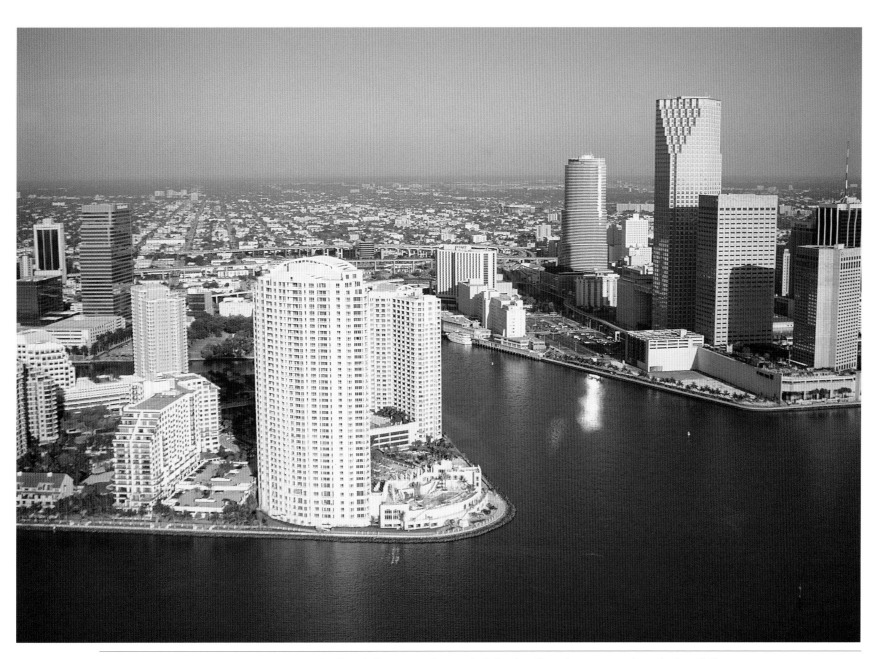

The Miami River enters Biscayne Bay just north of Brickell Key (seen here to the left). The tall condominiums at the end of Brickell Key are Tequesta Point One and Two. On the north side of the river are tall office buildings, including the Miami Convention Center. The river goes back along a seedier part of the city, including a stretch where small tugboats load and unload from the many warehouses along the shore. Fishermen also tie up along the river, as do yachts and house-boats. The round building on the right of the river is the Bank of America Tower, and the tall building to the right of that one is the Wachovia Tower. Next to that is the Miami Center, and to the right, where the river comes out, is the Intercontinental Hotel.

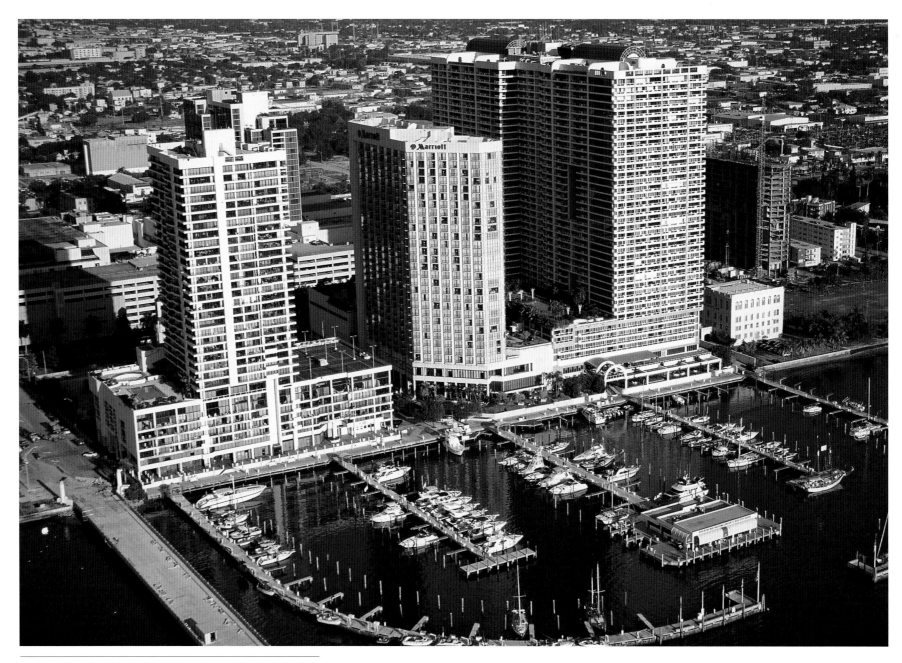

From left to right: the Plaza Venetia, the Biscayne Marriott, the Grand, and the Miami Women's Club, which was built in 1926 in the Spanish Renaissance style.

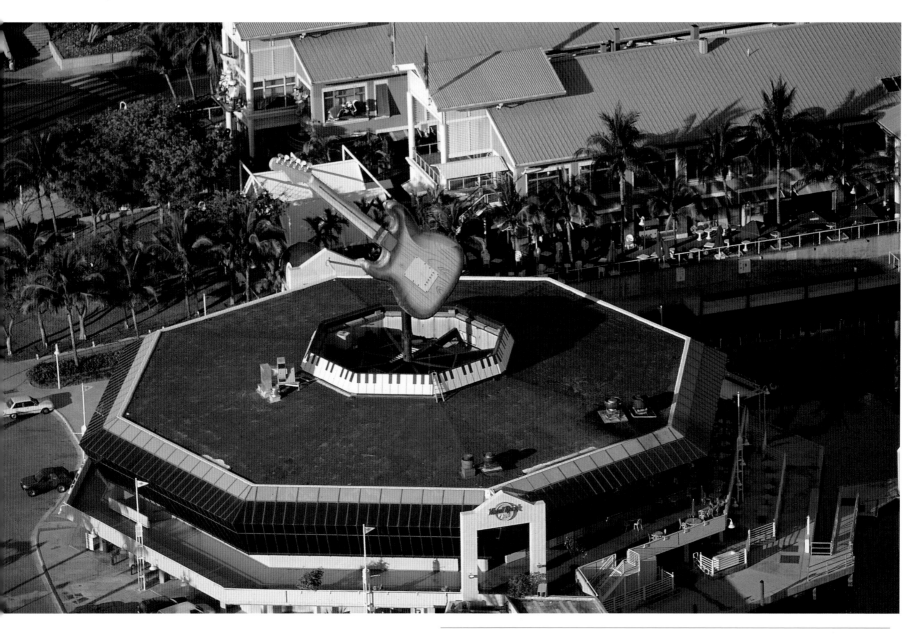

The Hard Rock Café, just one of the restaurants in the busy, popular Bayside Marketplace, has a lot of memorabilia from Latin superstars like Gloria Estefan and Jon Secada. The large neon guitar on top of the restaurant is a well-known landmark. Just south of Bayside Marketplace is Bayfront Park, a large green expanse built in the 1920s from earth dredged out of Biscayne Bay. There, in 1933, an assassin almost killed President-elect Franklin Roosevelt, but instead shot and killed Chicago's mayor, Anton Cermak.

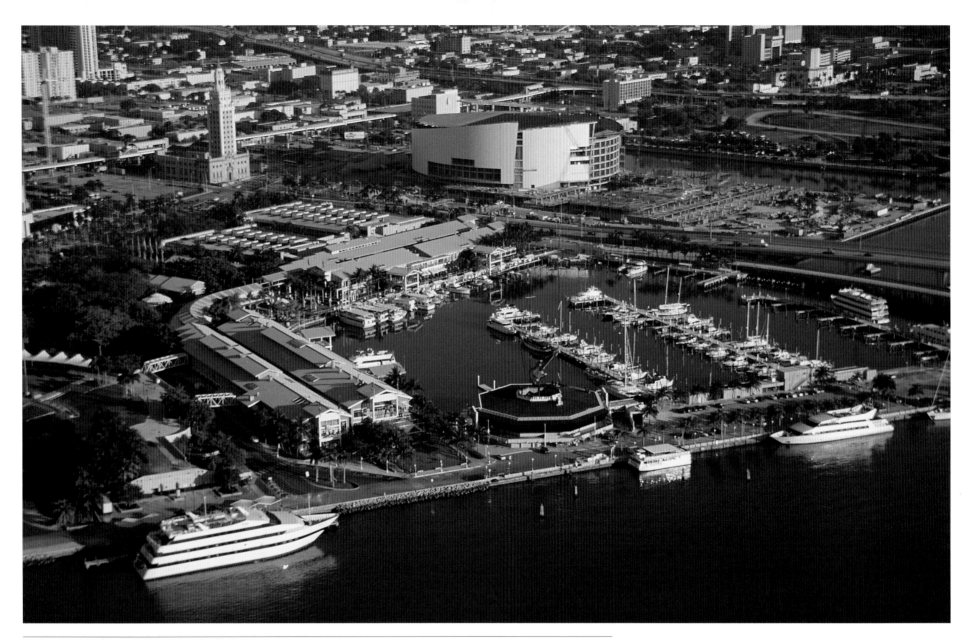

Bayside Marketplace has the American Airlines Arena in the background and much activity in the foreground, including restaurants and small shops. Cruise ships dock nearby, sightseeing boats sail by, and even a gambling boat leaves from there for offshore betting. The Marketplace, which opened in 1987, has over 150 shops, restaurants, and bars that cater to residents and visitors, such as the thousands of South Americans who fly up to Miami to shop. The American Airlines Arena hosts the Miami Heat of the National Basketball Association, as well as concerts and performances.

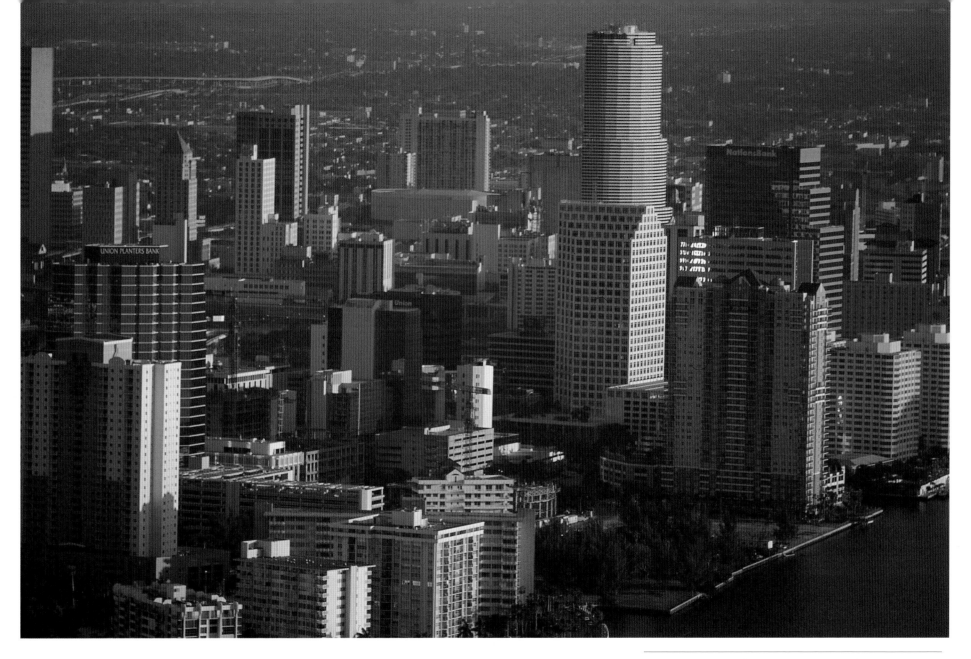

Downtown Miami, also known as the Central Business District, has high-rise office buildings along Brickell Avenue. The tall building in the center is the Bank of America Tower, which is in the midst of many apartment buildings.

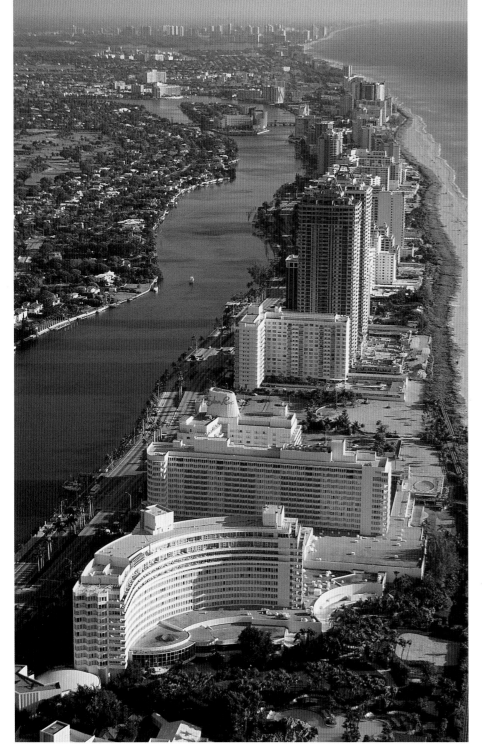

Miami Beach has high-rise condominiums and luxury hotels between the ocean and Indian Creek, including (from bottom to top) the Fontainebleau, the Eden Roc, and the Westin, some of the most famous hotels in Miami Beach. While the Fontainebleau hosted such entertainers as Lucille Ball, Elvis Presley, and Frank Sinatra in the 1950s, today it is a favorite with families because of its large grounds, children's play area, and swimming pool designed around a large, fiberglass octopus. The lavish architectural style of the 1950s-era hotels is known as Miami Modern or MiMo. They are just part of the county's 277 hotels and 189 motels, with a total of almost fifty thousand available rooms for rent.

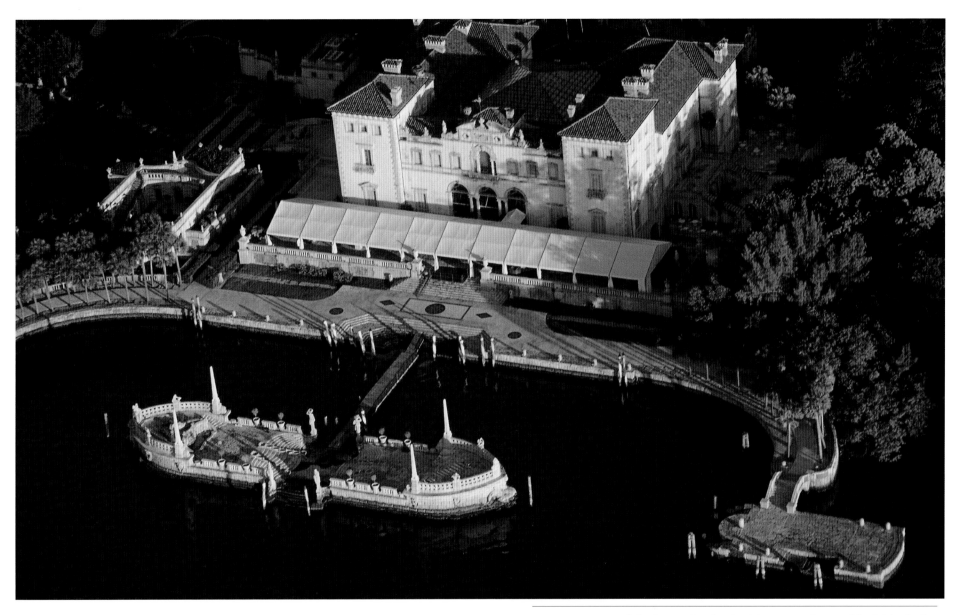

Vizcaya Museum and Gardens on South Miami Avenue, southwest of the Rickenbacker Causeway, is an Italian Renaissance–style villa open to the public. Industrialist James Deering built it in 1916 using one thousand workers, which made up ten percent of the local population at that time. The thirty acres have beautiful gardens, fountains, sculptures, pools, and a gazebo. The stone barge in the water in front of the mansion acts not only as a breakwater, but also as a beautiful reminder of the Venetian motif of the house.

35

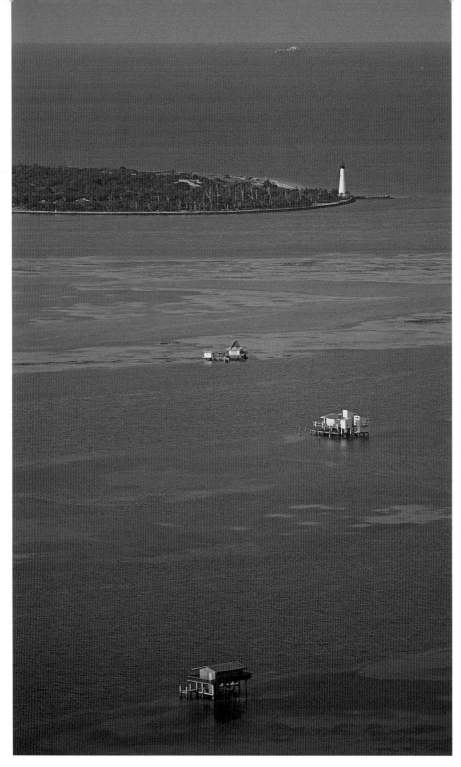

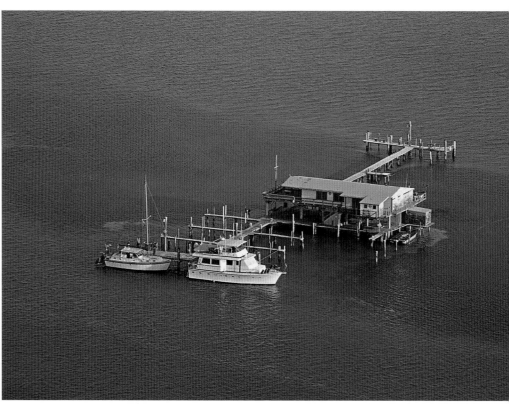

Only six houses are left in Stiltsville, which is off the southern tip of Key Biscayne where Biscayne Bay meets the Atlantic Ocean. These fishermen's bungalows in Biscayne National Park are all that remain of a once-thriving community, most of which has been destroyed by hurricanes. Preservationists want to save them, not for their owners to continue using them, but because the structures represent a unique part of Miami's architectural heritage.

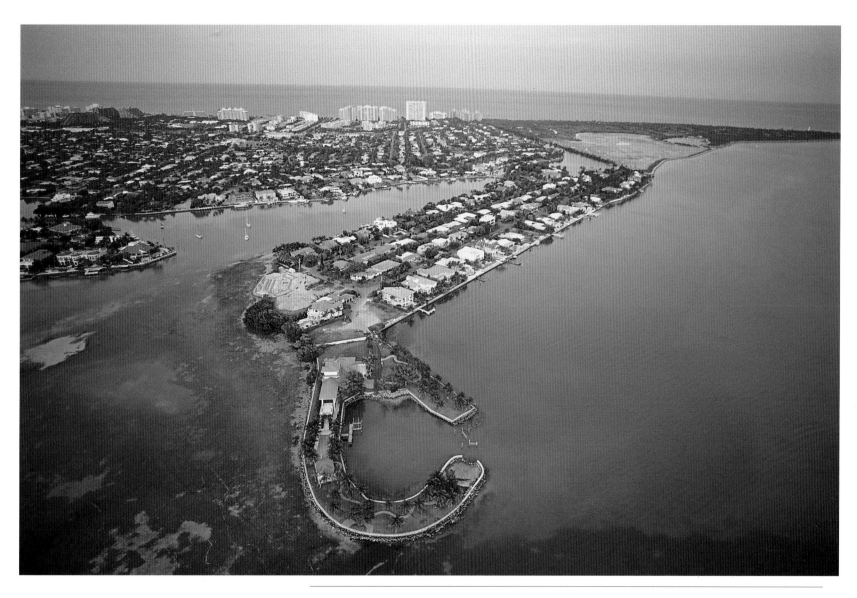

Southwest Point and Hurricane Harbor are on the island of Key Biscayne. The island, which Rickenbacker Causeway joins with the mainland, has luxury apartments and large mansions as well as a state park at the south end. Some famous personages, including former President Richard Nixon, have had houses on Key Biscayne, as do many people who enjoy the biking, swimming, windsurfing, and fishing that the island offers. Although originally developed as a farming community, it was acquired by the Matheson family, who operated a large coconut palm plantation there for many decades.

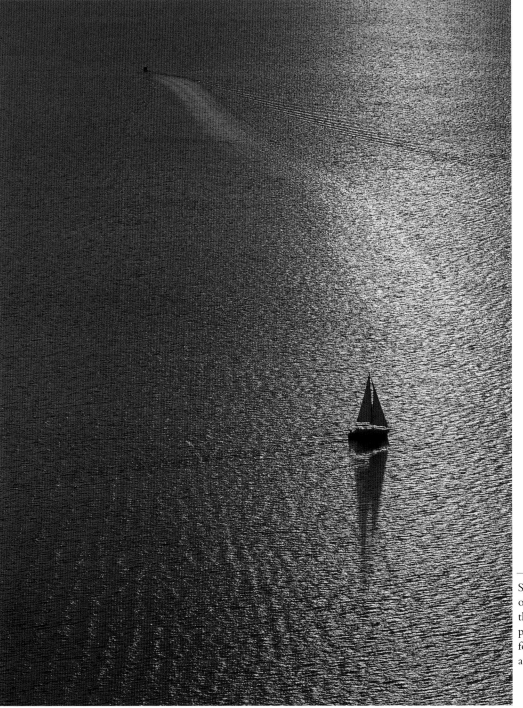

Sailboat at sunset on Biscayne Bay. The name of the waterway may go back to the Bay of Biscay in the Atlantic Ocean north of Spain and west of France. Or it may refer to the wreck of a ship belonging to a man named El Biscaino, who was from the Spanish province of Biscaya. The first European to visit the bay was Ponce de León in 1513, followed later by Spanish missionaries, Bahamian fishermen, runaway slaves, and settlers attracted to the spectacular setting of the bay.

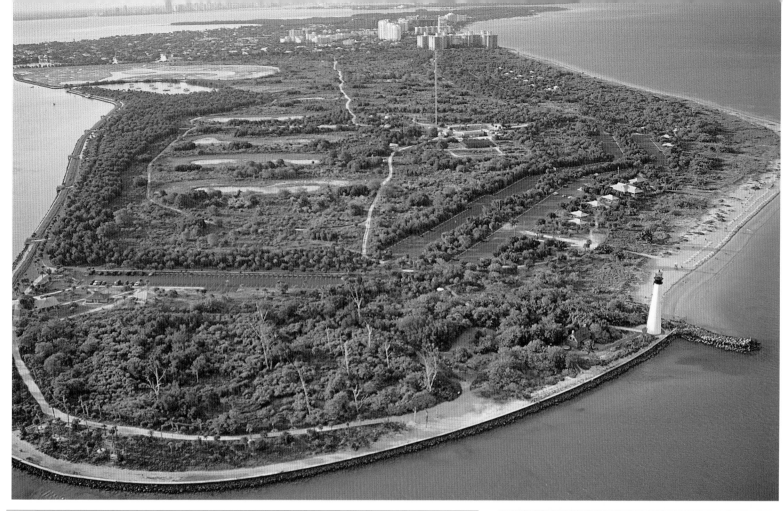

The southern part of Key Biscayne is Bill Baggs Cape Florida State Recreation Area, which was named after a Miami newspaper editor who had promoted the idea of a state park there. The high waters formed by Hurricane Andrew in 1992 poured salt water into the park, destroying many of the plants, and the 200-mile-per-hour winds blew down trees, but rangers have succeeded in replanting much of the park with tougher indigenous plants and trees in the hope that they will withstand future storms. A wide boardwalk stretches the length of the park and has picnic shelters all along it.

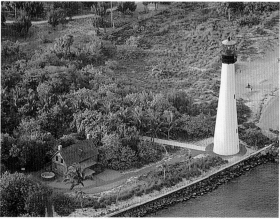

Cape Florida Lighthouse in Bill Baggs Cape Florida State Recreation Area was commissioned by Congress soon after the United States acquired Florida from Spain in 1821. The towers there (the present one is the second one) marks the reef four miles offshore and guides ships through the Florida Channel. When engineers built the Fowey Rocks Lighthouse seven miles southeast of Key Biscayne in 1878, the Cape Florida Lighthouse closed down. The Coast Guard reopened it in 1978, painted it white the way it used to be, and began using it as a navigational aid to help prevent boats in the vicinity from running aground.

Sand mining near the Florida City area extracts sand for use in construction. The sand there is valued in the construction industry because of the quality of the commercial-grade silica sand. Florida City was one of the hardest-hit Florida towns when Hurricane Andrew came ashore in 1992, packing 200-mile-per-hour winds and a twelve-foot-high tidal wave. It destroyed over 60,000 homes, left 150,000 people homeless, and caused $25 billion worth of damage.

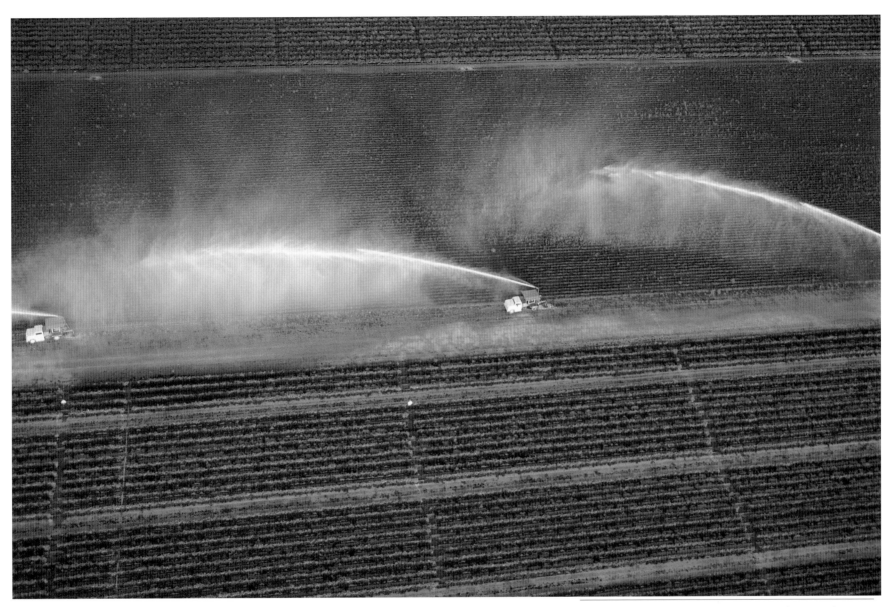

Watering farm fields in Homestead. The rural nature of Homestead exemplifies what Miami used to be like: rich farm land, two-lane roads, pickup trucks everywhere, and small-town friendliness. In addition to the traditional farms there are now organic farms, which cater to the health-conscious demands of today.

Discarded fruit in plowed fields outside Homestead, possibly after a hurricane passed through.

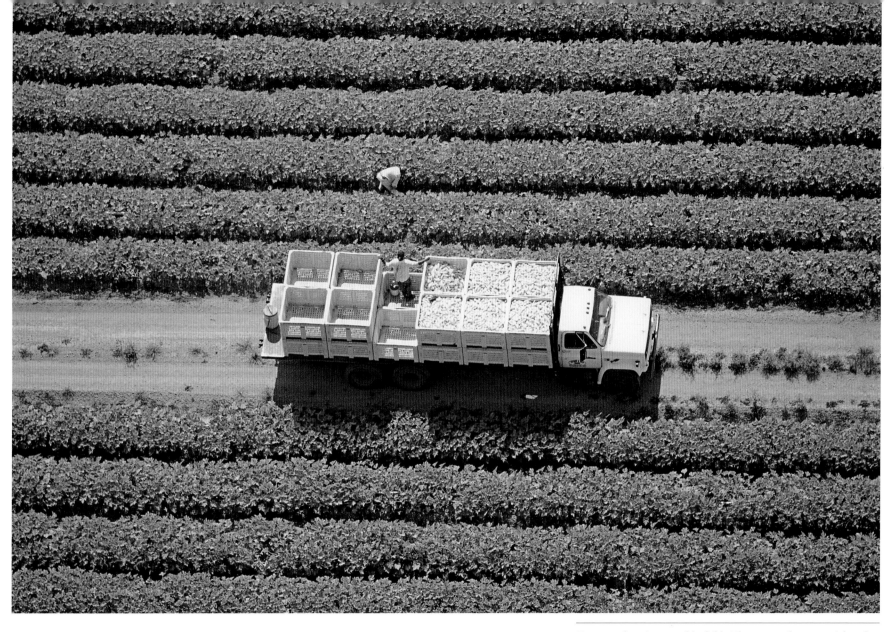

Farm workers in vegetable fields. The county has over eighty-five thousand cultivated acres, and relies on workers from here and abroad to bring in the harvest.

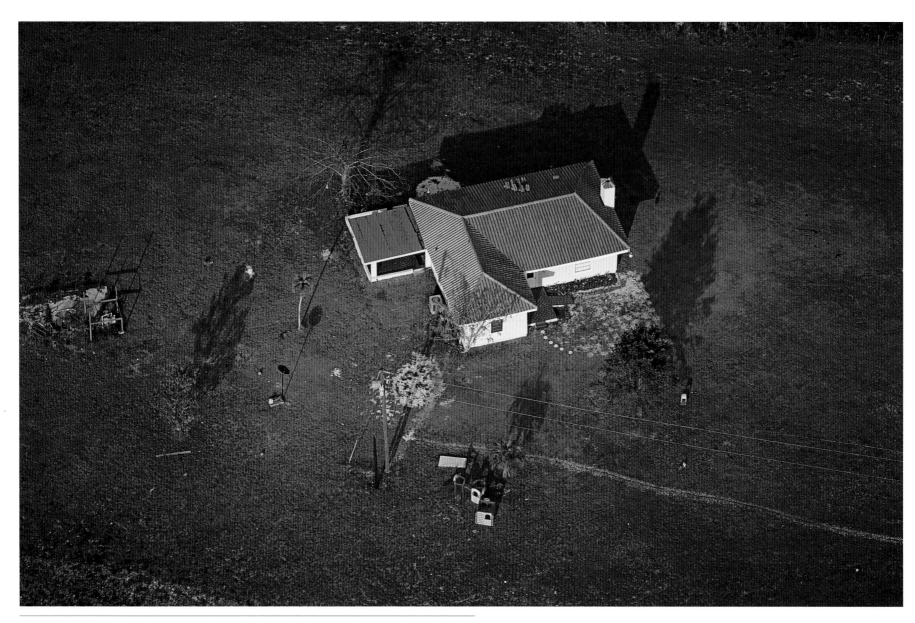

An isolated house in Homestead indicates how uncrowded Miami-Dade County can be away from the city of Miami. Homestead was badly damaged when Hurricane Andrew came ashore in August 1992. The central pressure of the hurricane was 27.23 inches, which made it the third most intense hurricane on record to hit the United States. Andrew's peak winds in south Florida were not directly measured due to destruction of the measuring instruments, but scientists estimate that sustained winds measured 150 miles per hour.

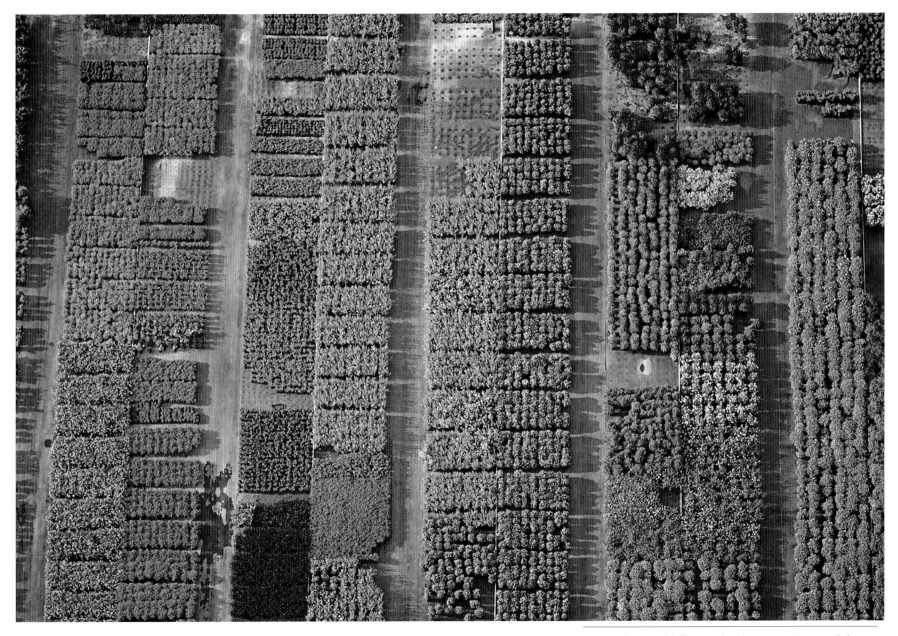

Acres and acres of different colored crops in Homestead show the trend of moving more and more toward culitvating exotic fruits and plants due to the growing demand for such species, which thrive in the south Florida climate.

Because Homestead is relatively close to the rich soil of the Everglades and has an average temperature of 75 degrees, farmers can grow many different types of plants and vegetables there.

THE EVERGLADES

The land between two of the most developed sections of Florida, Miami to the east and Naples/Ft. Myers to the west, is mostly uninhabited by human beings, but has thousands of creatures and a myriad of plant life—though conservationists are quick to point out that what remains is a small percentage of the abundance of wildlife that once thrived in the Everglades.

When members of the Florida Federation of Women's Clubs became concerned about the drainage of the Everglades in 1916, they bought a large piece of land which they called the Royal Palm State Park. That plot of land became the nucleus of the Everglades National Park, which the federal government established in 1947. Much of the impetus behind the national park was the crusading done by Marjory Stoneman Douglas, who wrote *The Everglades: River of Grass* and championed the preservation of the Everglades before developers drained it for more houses and shopping malls.

The Everglades is a very slow-moving body of water flowing from the Kissimmee River down to Florida Bay, a distance of two hundred miles. The depth of the water is only about 6 inches. Sawgrass covers about four million acres of wet prairie, which, interestingly, is at the same latitude as the Sahara Desert in Africa.

The park contains around 350 different kinds of birds, 500 kinds of fish, forty mammal species, and fifty-five species of reptiles. Around four dozen species of plants are unique to the Everglades and can be found nowhere else in the world.

Although Native Americans arrived over two thousand years ago, in general they lived in harmony with nature and did not harm the environment the way the white men did, beginning in the nineteenth century.

Because of the increasing land and water demands of the approximately nine hundred people a day who move to Florida, engineers have for decades drained more and more of the Everglades, shipped its water to the thirsty southeastern coast, and built roads throughout. The people of Miami-Dade County use 650 million gallons of water a day. At one point, engineers wanted to build a huge airport in the Everglades to relieve the increasingly busy Miami International Airport, but environmentalists stopped that project.

Although Mother Nature will continue to make her presence known—in the hurricanes that will always be a threat, for example— enough people have banded together to preserve what is left of the Everglades to give hope to the future. ☀

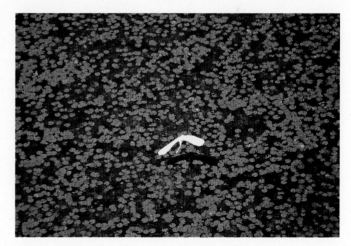

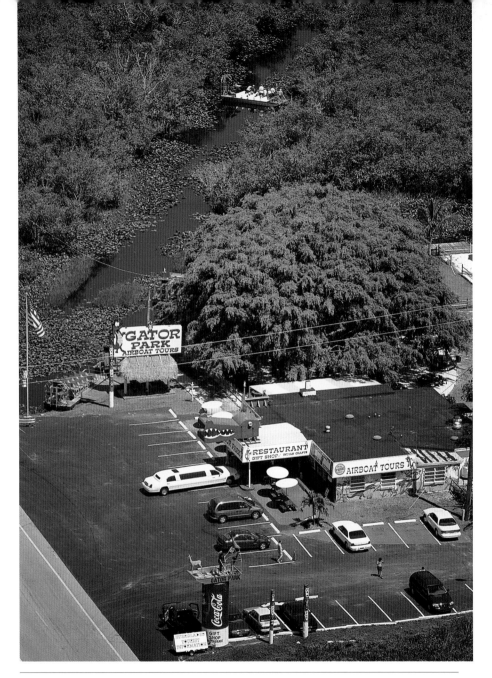

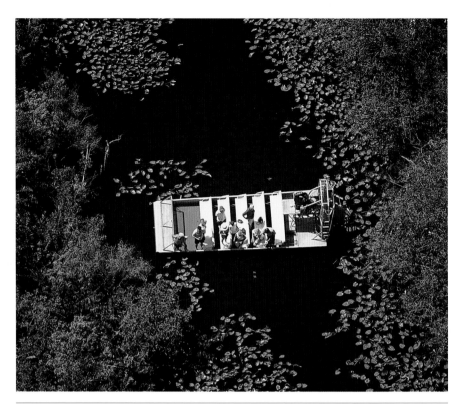

Because airboats can skim over the wet marshes, providing a very stable ride, they are the only method of transportation to take far into the Everglades. The powerful aircraft engines that propel the boats allow them to reach speeds of 45 miles per hour. Visitors can take airboat tours from several places along U.S. 41, the Tamiami Trail. Despite what many think, airboats do cause environmental damage. They leave a trail, which opens channels that can cause a faster flow of water than normal. Also, such channels can carry pollutants into sensitive areas. The noise of the airboats can disturb wildlife, including birds and alligators.

Gator Park on the Tamiami Trail (U.S. 41) offers airboat rides into Everglades National Park, as well as displays with turtles, macaws, peacocks, and snakes.

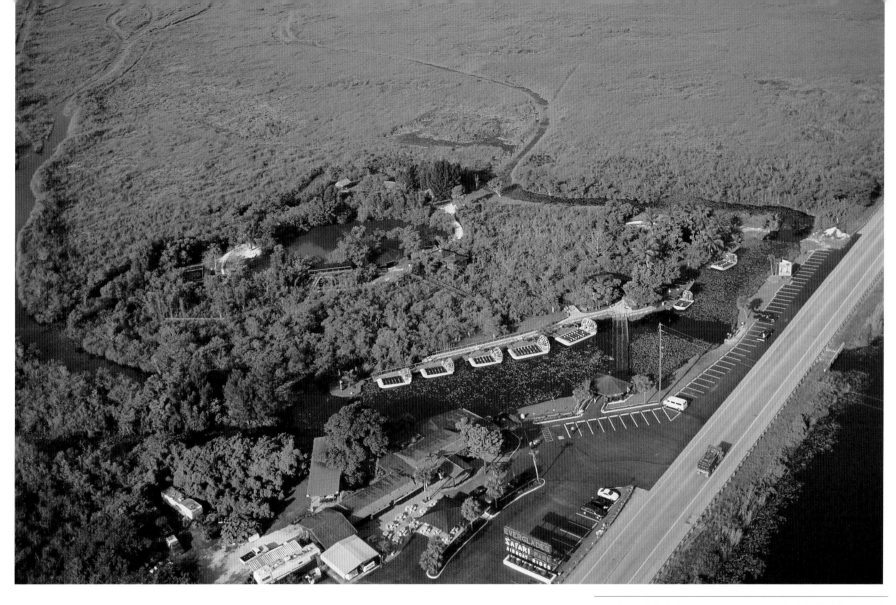

Everglades Safari Park near the Tamiami Trail (U.S. 41) west of Miami offers airboat rides, eco-adventure tours, alligator shows, and a Jungle Trail leading to an alligator farm with over 400 gators and crocodiles. It also has a replica of a chickee village used by Native Americans.

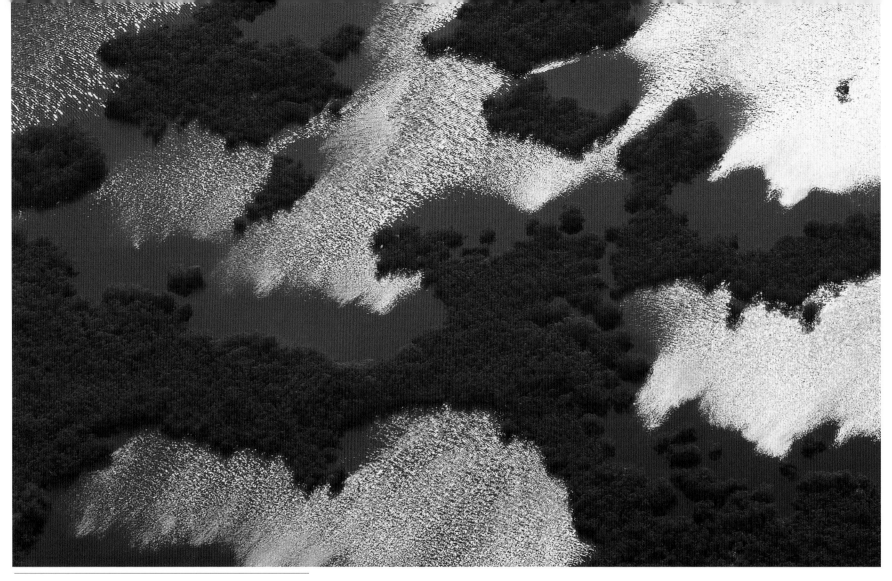

The Everglades at sunset offers spectacular views of natural Florida. The Tamiami Trail, which was built to join Tampa and Miami, was the first road to open up the Everglades by linking the Atlantic and Gulf coasts. Everglades National Park covers about one-fifth of the Everglades and allows visitors to see some of the teeming wildlife in the surrounding swamps.

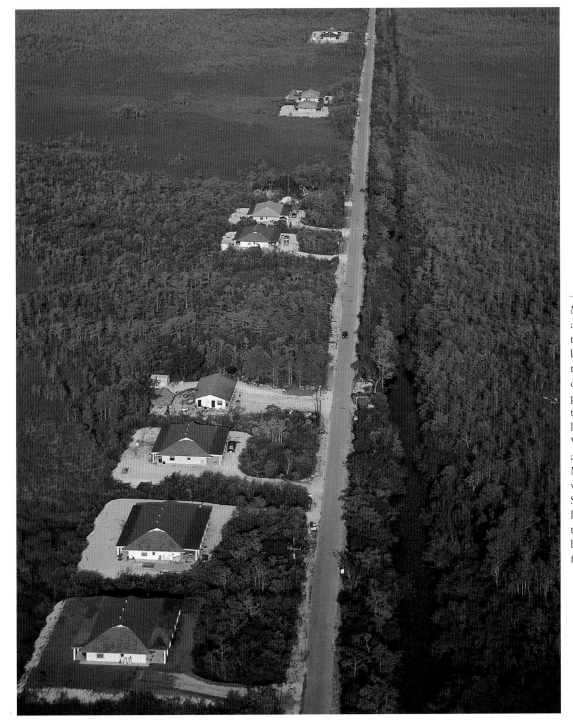

Modern homes on the Miccosukee Tribe Reservation off U.S. 41, about mid-way between Miami and Naples, have replaced the thatched chickees, which are open-sided huts covered by palmetto branches. Nearby is the tribe's community center; visitors can tour the facility and see displays about the Native Americans, as well as demonstrations of their traditional crafts like beadwork, palmetto-palm dolls, and baskets. A particular favorite in the public restaurant there is Indian tacos: fried bread covered with a spicy meat spread, lettuce, and tomatoes. Visitors can also visit the Miccosukee Indian Village and see alligator wrestling, dugout carving, basket weaving, and other activities of the Native Americans living in the vicinity. Most of the Miccosukees live either near the community center or west along the Tamiami Trail, which continues on to Big Cypress Swamp. The Miccosukees, who are separate from the Seminoles in language, customs, and beliefs, were not officially recognized as a tribe until 1962. They run a bingo operation near Miami which brings in money for the tribe and helps fund educational programs for all its members.

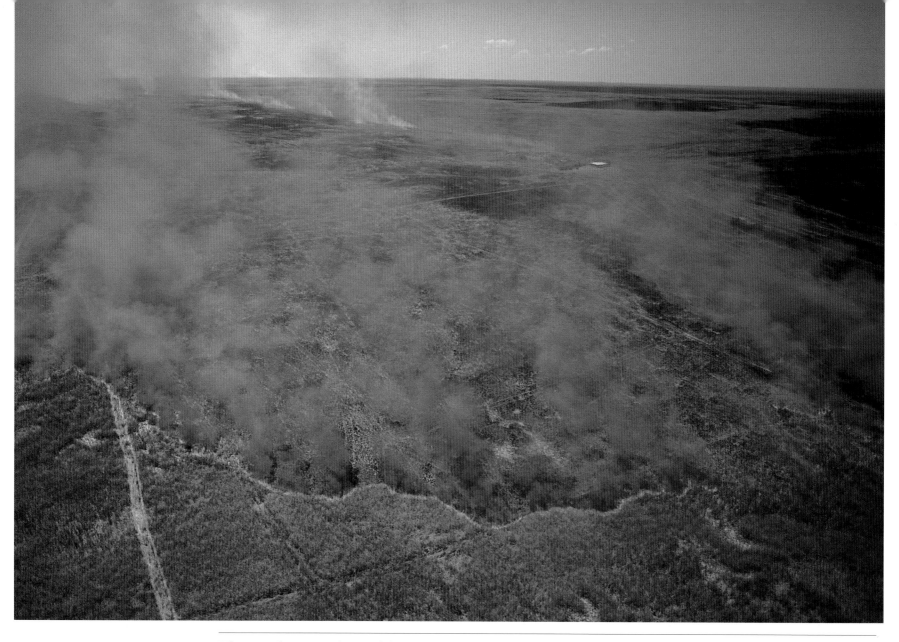

Whenever a fire starts in the Everglades, it can be very difficult to extinguish. Many parts of the Everglades are inaccessible to fire engines, dry seasons make the vegetation very combustible, and the drained swamps cannot stop the fire. At such times, the smoke from the vast fires fills the sky and makes driving on Alligator Alley and the Tamiami Trail dangerous, even hindering the visibility of airplane pilots in south Florida. Fire actually plays an important role in the ecosystem of the Everglades in that it prevents the spreading of woody plants, which could have a negative effect on the other plant species of the swamp. Sometimes trained personnel deliberately start fires in the isolated areas around Homestead to reduce accumulated plant debris, control exotic plants, and maintain habitat for natural species. Fires destroy hammock species that would otherwise take over with their dense canopies. Lightning-caused fires usually start in the prairies and are permitted to burn because there is no threat to human life.

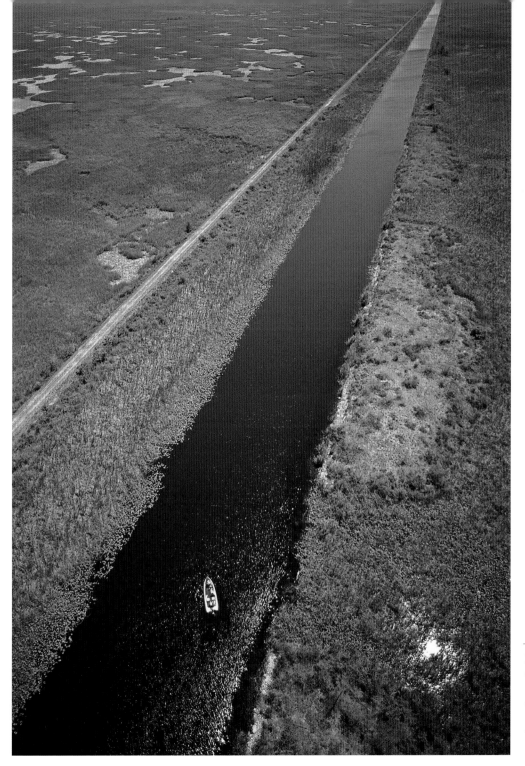

Beginning in the early twentieth century, engineers built canals in the Everglades to drain more of the swamp and to control the overflow of Lake Okeechobee by having an outlet to the Atlantic Ocean for the water entering the lake from the north. One of the unforeseen problems with those canals was that they reversed their flow of water during periods of low water. The water would actually flow back into Lake Okeechobee rather than into the Gulf of Mexico or Atlantic Ocean.

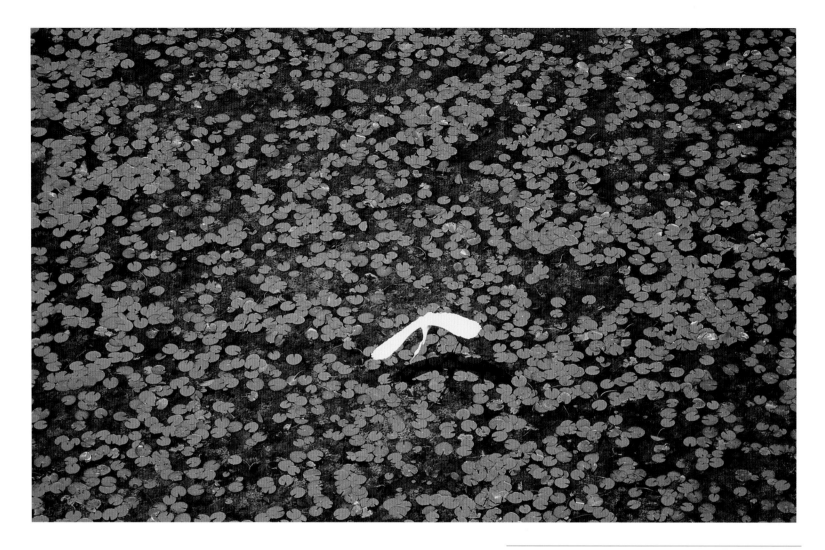

A white egret soars above the lily pads in the Everglades. While the bird life in the Everglades is recovering, it is nowhere near what it was up until the early twentieth century when huge flocks were common. But plume hunters, eager to take advantage of the $28 per ounce for heron feathers that New York buyers were paying, killed millions of birds so that wealthy ladies could wear plumed hats in Paris, London, and New York. A particular favorite of the hunters was the egret, especially during nesting seasons, because of the beautiful feathers that the birds have to signal their readiness to mate. That plumage sold for $32 per ounce, which was also the price of gold in 1915. ☀

BROWARD COUNTY

Broward County and its chief city, Ft. Lauderdale, lie just north of Miami-Dade County, and also has a diversity of population with almost 21% African American and 17% Hispanic.

In the 1960s Ft. Lauderdale became associated with spring break, intoxicated collegians, and wild parties. The 1960 movie *Where the Boys Are,* starring Connie Francis, made the city the epitome of spring break for collegians, especially from the cold Midwest and Northeast. In time, the residents got tired of all the shenanigans, and the spring breakers moved to Daytona Beach, where the prices were cheaper. Since then Ft. Lauderdale has become more family-oriented and has thousands of dining and wining establishments that consistently win acclaim from travel writers.

Named for Governor Napoleon Bonaparte Broward, who made his claim to fame by draining much of the Everglades for farming and development, the county suffered through the importation of illicit drug money in the 1980s, but has since been able to attract over five million visitors a year and countless families that want to settle in a balmy climate and beautiful surroundings, often on manmade canals. ☀

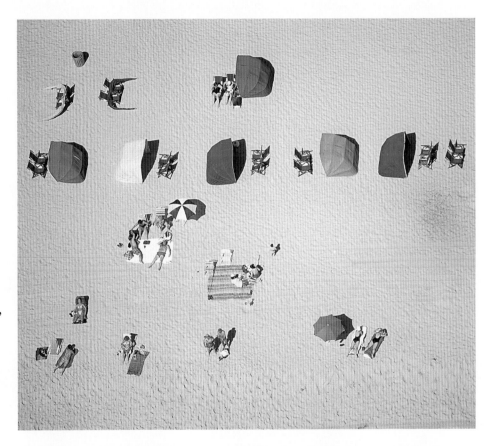

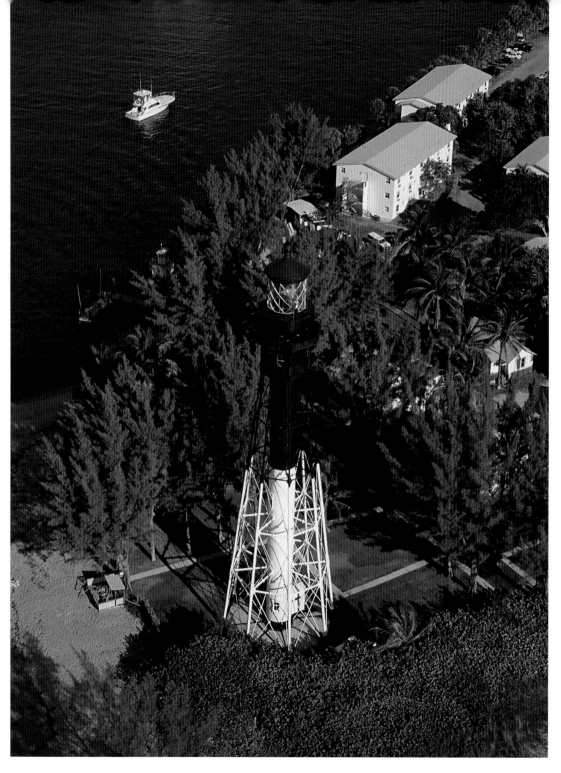

Hillsboro Inlet Lighthouse in Broward County marks the entrance to the treacherous Hillsboro Inlet and the northern limit of the Florida Reef, the cause of many shipwrecks. The building of that tower also completed the line of lighthouses on Florida's east coast so that mariners passing from the light range of one would be in the light range of the next. This particular lighthouse was built for the 1904 Great St. Louis Exposition, then disassembled, shipped to Florida, and reassembled here in 1907. The white color of the lower third enables boaters to see it against the background of trees, and the black of the top shows up against the daylight sky.

The cruise ship *Imperial Majesty* enters the Turning Basin in Ft. Lauderdale, a very busy place for cruise ships and cargo carriers. The city has over 165 miles of navigable waterways and canals, which gives it the nickname "Venice of America." Over forty thousand boats use those waterways. The basin takes its name from the fact that the large ships turn around there before or after docking and before heading out to sea.

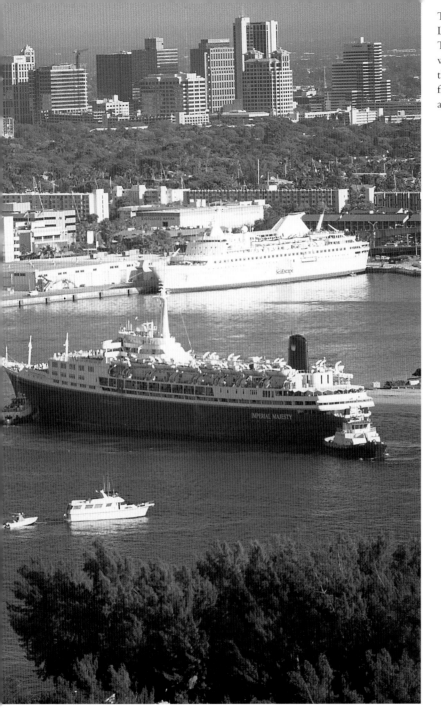

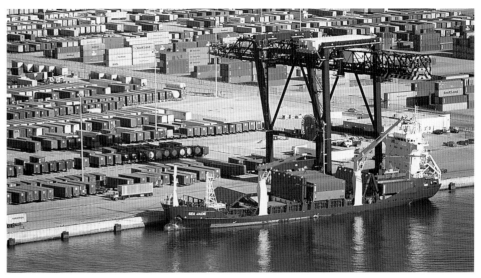

A container terminal at Turning Basin in Ft. Lauderdale.

A ship enters the Turning Basin. When cruise ships leave from there, often on Saturday or Sunday evening, people in the apartment buildings along the channel come out to wave, toot their horns, and wish the passengers "bon voyage."

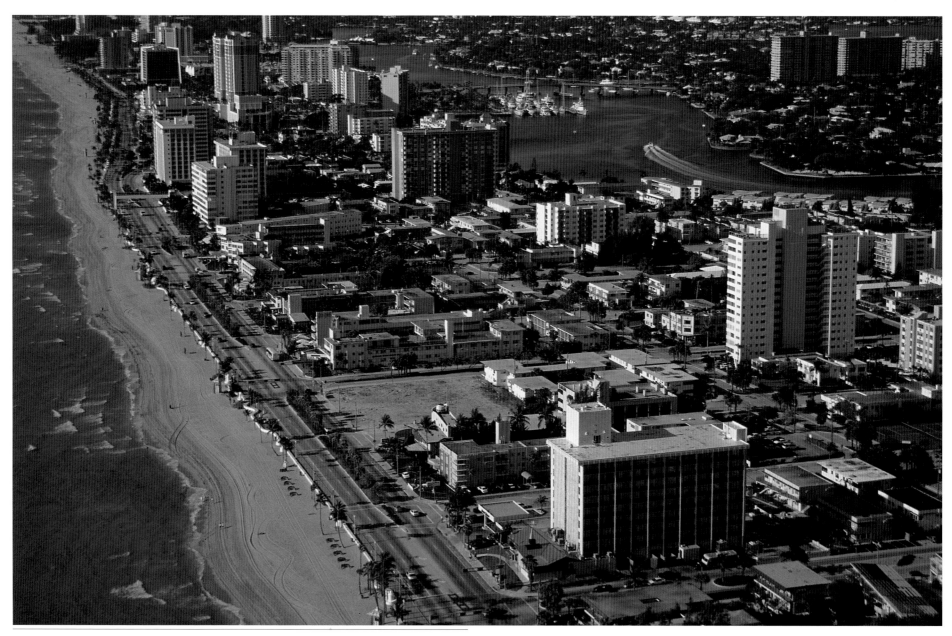

Ft. Lauderdale Beach is a very popular beach with the public because, unlike in Miami Beach, there is no building encroachment. Many events and festivals are held here. The beach is also less rowdy than in the days of spring breakers because city officials have built a wall between the beach and the bars that line Atlantic Boulevard, a wall meant to keep party-goers more contained. The biggest spectator event there now is the annual Air and Space Show, something that attracts families and the many retirees who moved to Broward County to enjoy their senior years.

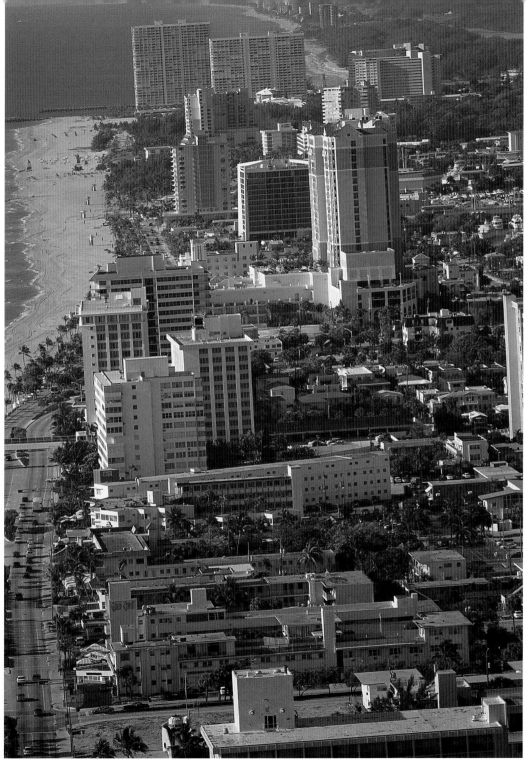

The coast in Broward and Palm Beach Counties is known as the Gold Coast, not only because of the treasure from Spanish shipwrecks found offshore, but also because of the expensive high-rises along the beach. The coastal strip from Miami north to Palm Beach is a growing metropolis as more and more people move in to take advantage of the weather and attractions of south Florida.

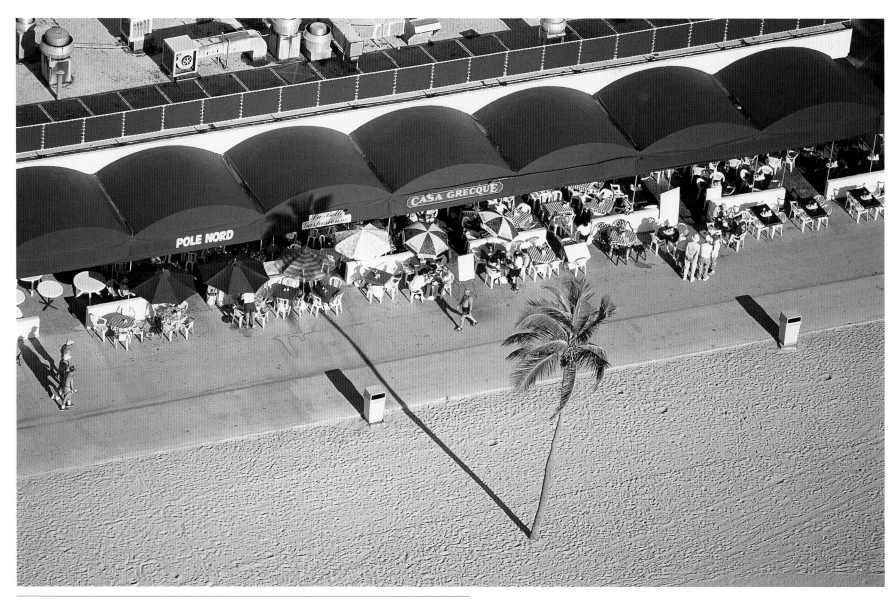

Restaurants and cafés along the Hollywood Beach Broadwalk attract a chic crowd. It also attracts casually dressed beach-goers in search of sustenance. Because of all the huge yachts that winter in the city, Ft. Lauderdale is known as an international yachting center.

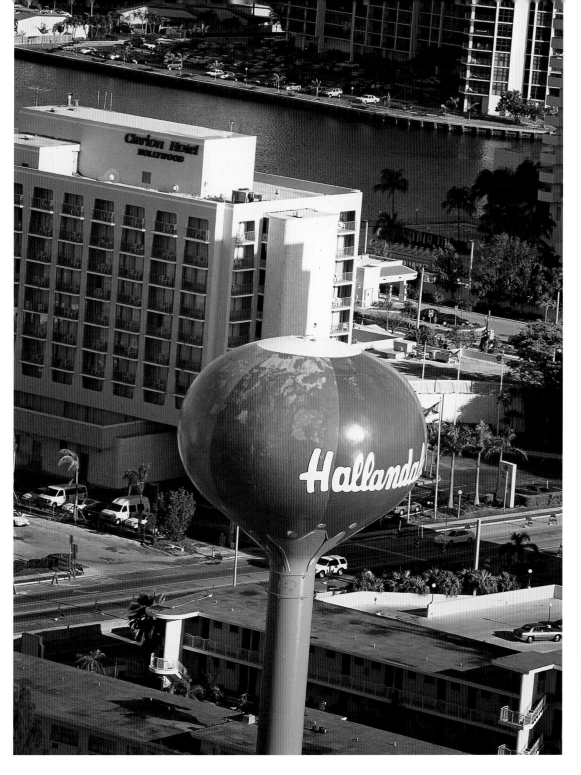

The town of Hallandale has been officially renamed Hallandale Beach. Incorporated in 1927, it was apparently supposed to be Hollandale since the majority of settlers there were Dutch, but the first vowel was changed for some reason.

An Art Deco hotel in Hollywood Beach has wonderful details in its rounded contours and banding. Although not as well known as the Art Deco hotels in Miami Beach, those along Hollywood Beach have a quiet elegance that harkens back to the 1930s.

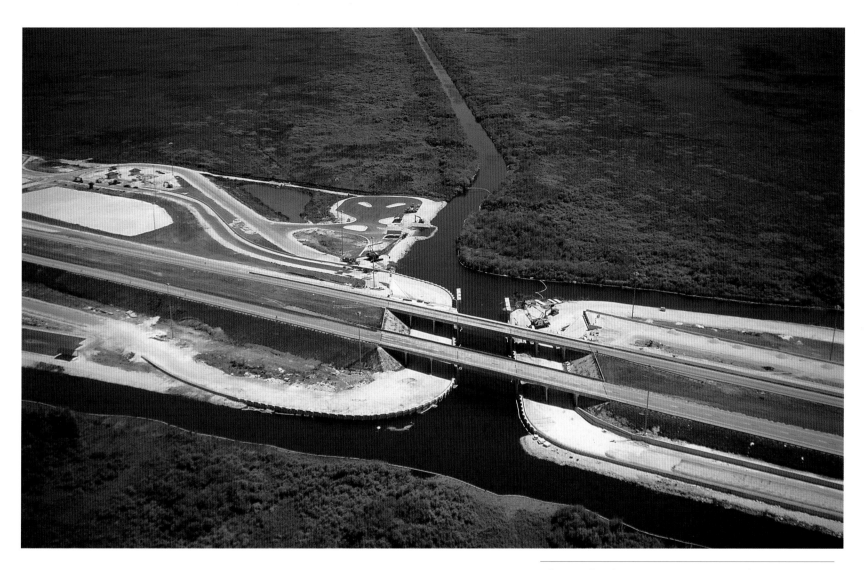

Alligator Alley, the more picturesque name of I-75 or the
Everglades Expressway, is a major east-west highway that crosses
south Florida and connects Ft. Lauderdale on the east coast with
Naples on the west coast. Drivers can see drainage ditches on
either side, which were built years ago to drain the Everglades,
before environmentalists pointed out how foolish such a scheme
was. There is also a fence on either side to keep wildlife, particu-
larly the endangered Florida panther, from the dangers of cross-
ing the highway. Since the wildlife does need to move, however,
tunnels were built and are being used by the animals.

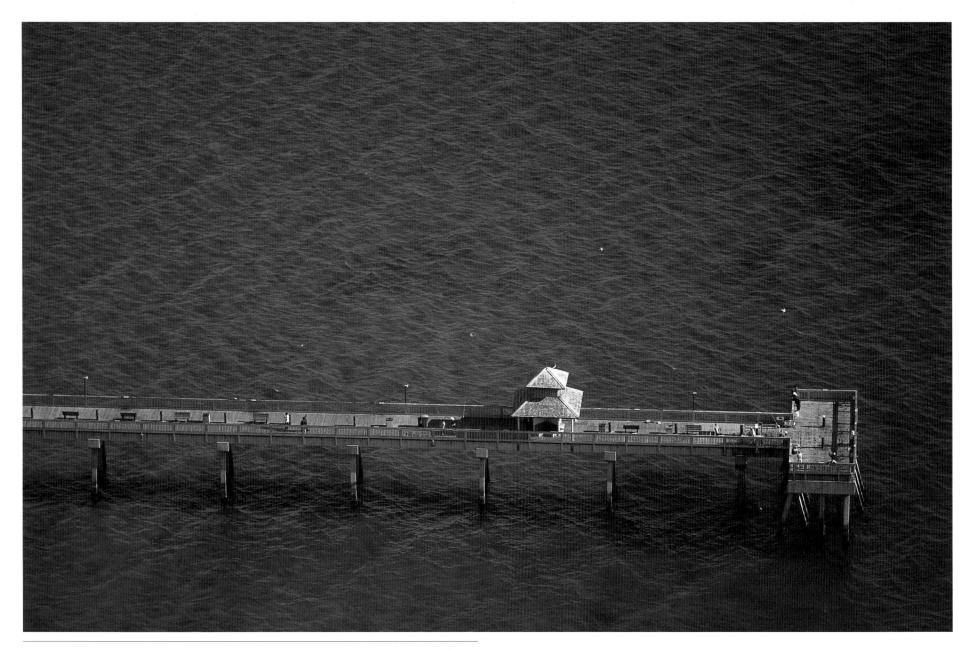

Avid anglers can fish off Deerfield Beach Pier twenty-four hours a day, seven days a week. Those who don't care for fishing can stroll along the pier for a small fee. Deerfield Beach, which is between Pompano Beach and Boca Raton, also has free surfing lessons near the pier every Saturday morning.

PALM BEACH COUNTY

Palm Beach County was carved out of Dade County in the early 1900s when Henry Flagler extended his railroad south and built hotels for the arriving passengers. The grandest hotel was The Breakers, which is still the choice of well-heeled Palm Beach visitors. It's a county of sharp contrasts between the coastal cities and the farms to the west near Lake Okeechobee.

The county runs from Boca Raton in the south to Jupiter in the north, including Delray Beach, Boynton Beach, and Lake Worth. Palm Beach, with its mansions and swanky shopping on Worth Avenue, is on a barrier island and has only about ten thousand residents. West Palm Beach, on the mainland, has a population of over a million.

There are 47 miles of Atlantic beach on one side of Palm Beach County and about 40 miles along the shores of Lake Okeechobee on the other side. The main industries are tourism, agriculture, and construction. That last one is no surprise as the county is growing fast, including huge housing developments marching west into the agricultural and wildlife areas. ☀

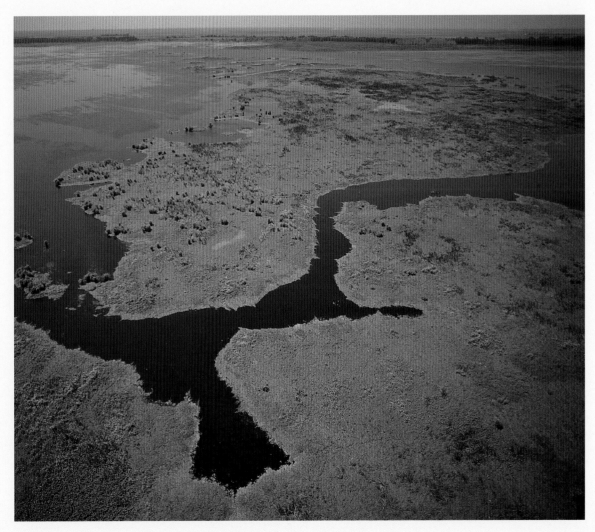

The photo here shows the South Bay area at the edge of Lake Okeechobee.

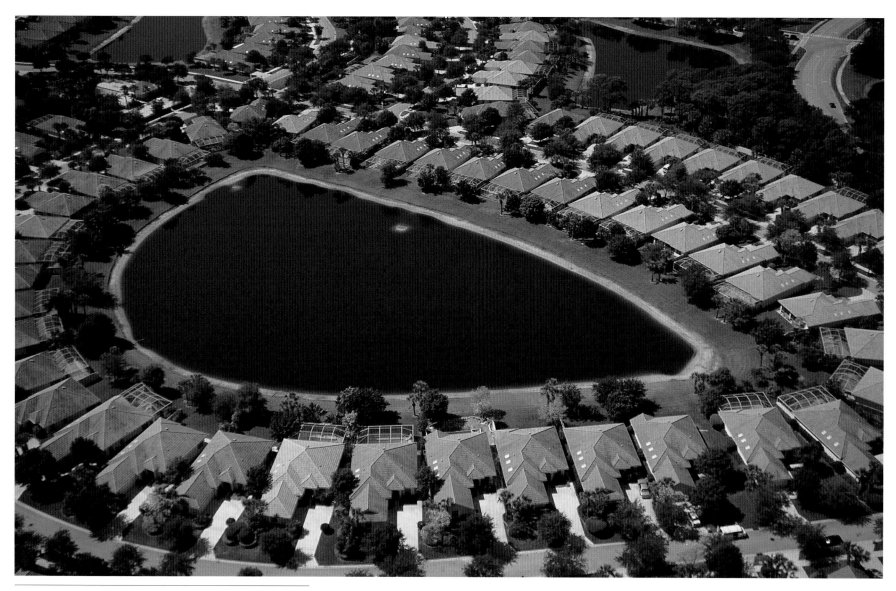

A housing development around a man-made lake in North Palm
Beach.

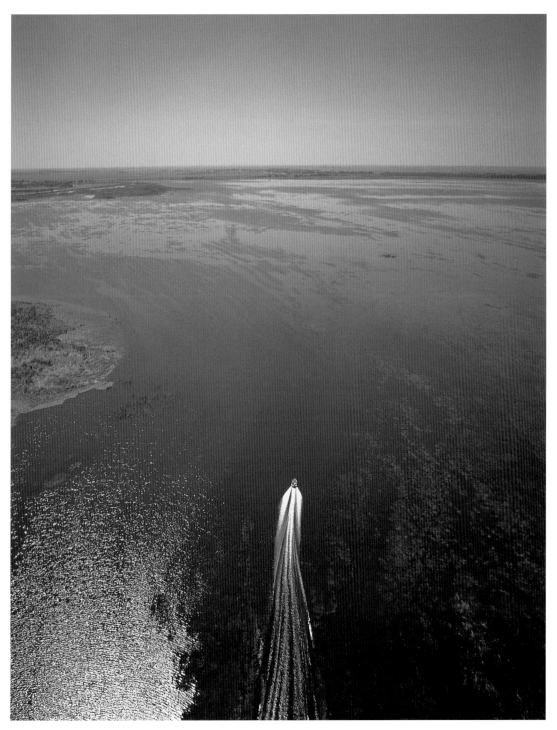

The 730 square miles of Lake Okeechobee make it the second-largest freshwater lake in the continental United States, second only to Lake Michigan. The Florida lake is relatively shallow, averaging only about 9 feet, but its drainage basin covers more than 4,600 square miles. Destructive hurricanes of the 1920s and 1940s, which sent walls of wind-driven water over the lake's edges and killed thousands of people, led to the building of a 30-foot earthen wall around much of the lake.

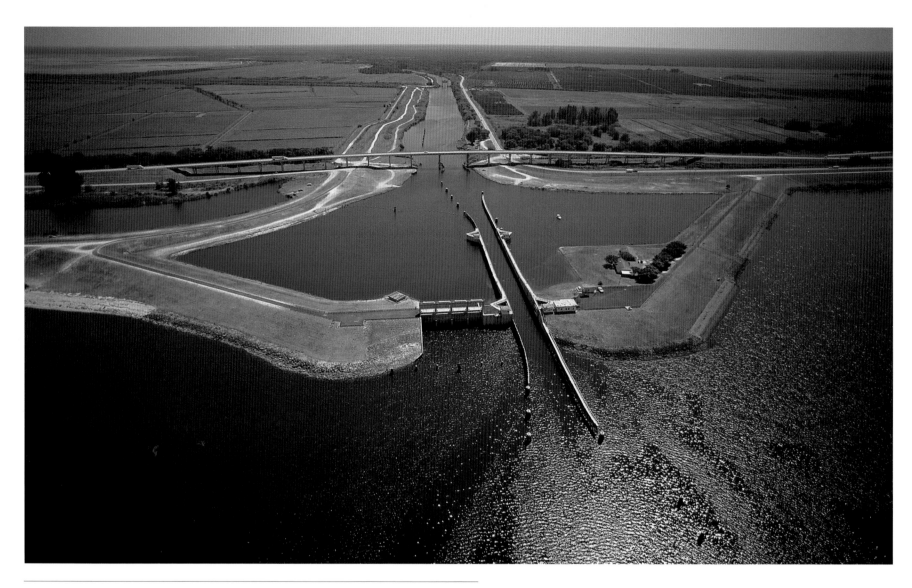

The St. Lucie Canal is part of the 152-mile Okeechobee Waterway that connects Florida's coasts. Port Mayaca, in Martin County, marks the entrance from the canal to Lake Okeechobee. The St. Lucie Canal flows northeast to Stuart. The waterway uses a series of locks and dams to maintain a navigable channel.

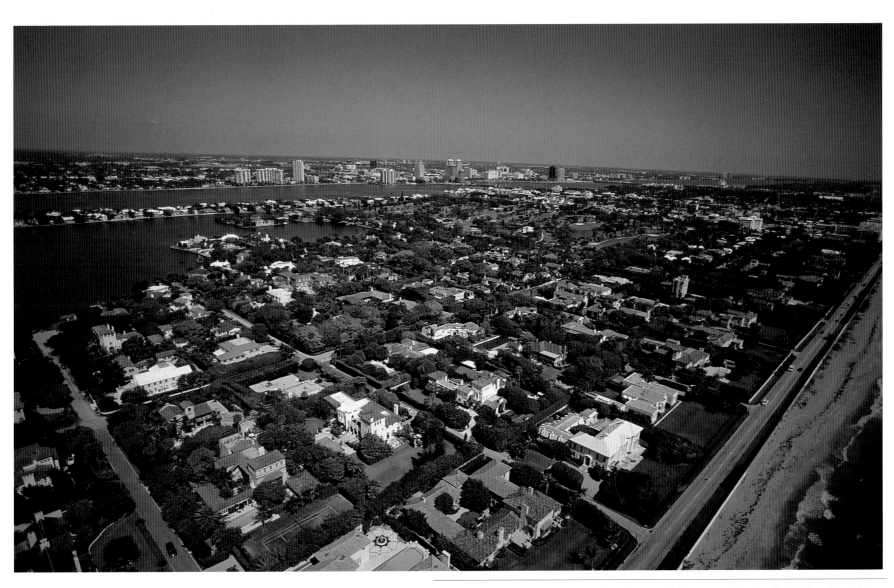

Lake Worth separates Palm Beach in the foreground from West Palm Beach with its white high-rises in the background. Developer Henry Flagler visited the area in the 1890s, liked what he saw, and eventually extended his railroad there. He built several luxury hotels near the ocean. In West Palm Beach he built commercial businesses and accommodations for his workers.

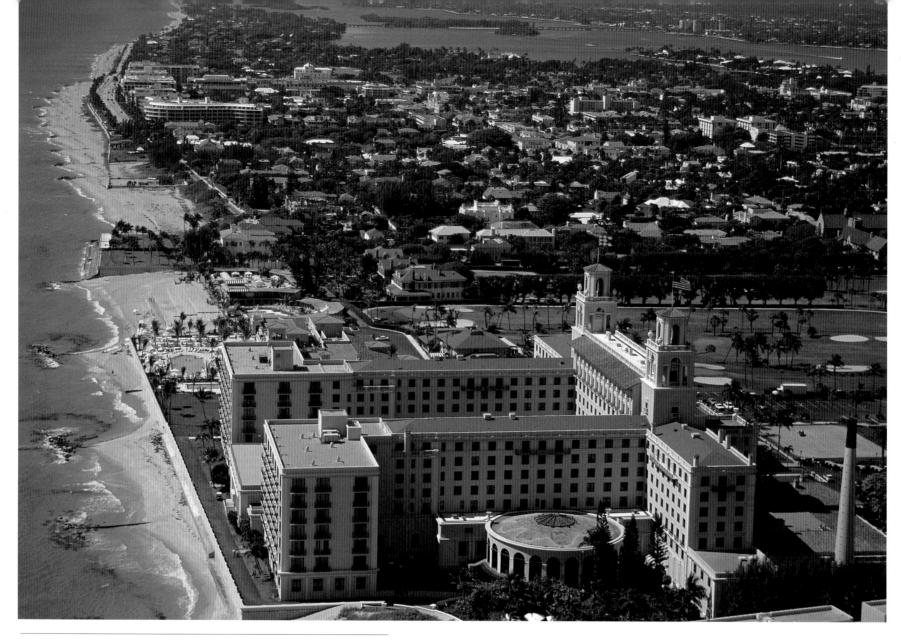

The Breakers in Palm Beach is one of the most magnificent hotels in Florida. In 1896, Henry Flagler built the Palm Beach Inn on the beachfront of the Royal Poinciana Hotel, but, when guests began asking for rooms "over by the breakers," he doubled the size of the inn and renamed it The Breakers. It burned down in 1903, but reopened within a year. In 1925, the all-wood building burned down again, but was rebuilt in 1926 and continues to be a favorite resort of the rich and famous.

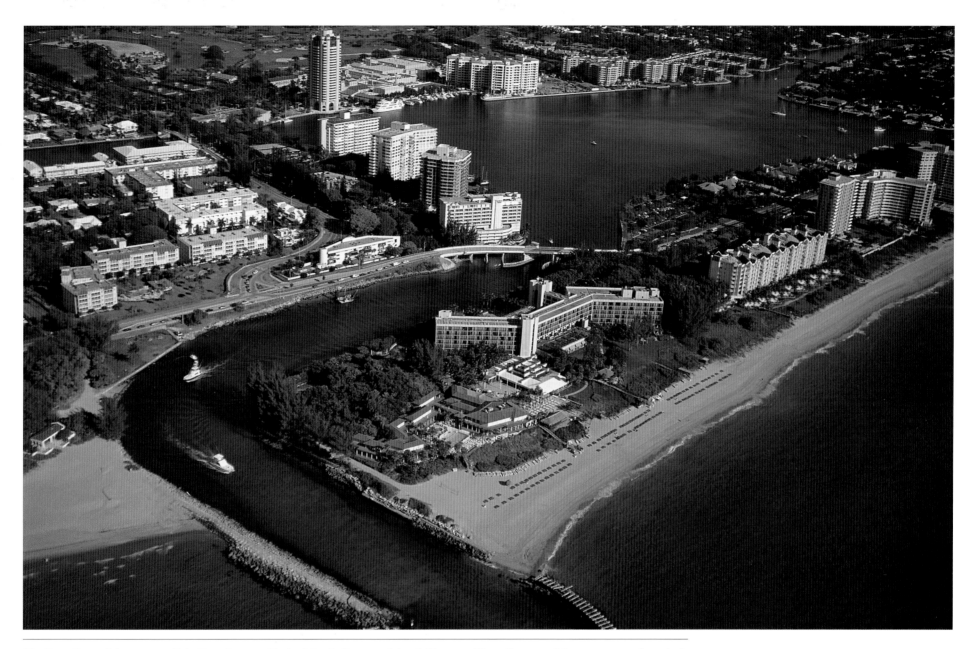

The Boca Raton Inlet connects Lake Boca Raton with the Atlantic Ocean and the Gulfstream offshore. Because of the ocean access through the inlet, developers have bought some of the older homes, torn them down, and built multi-million-dollar mansions with thousands of square feet of living space and room for entertaining. The Boca Raton Resort and Club, which began as The Cloister Inn when it was built in 1926, is visible at the top of the photograph. The hotel was designed and built by architect Addison Mizner, whose vision helped transform Boca Raton from a farming community into a thriving resort community.

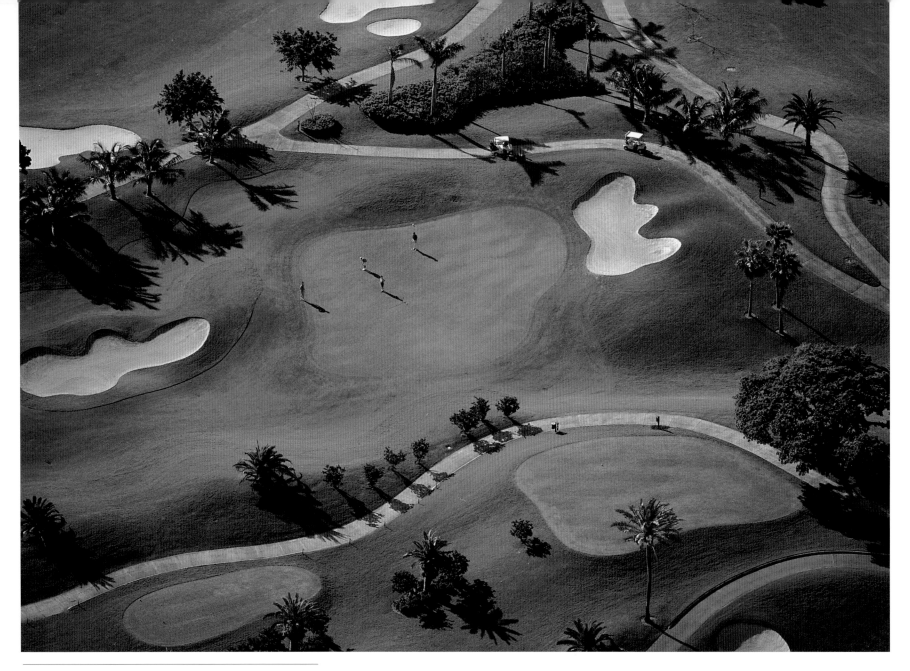

This golf course in Boca Raton is just one of a hundred in southeast Florida. The state has over a thousand courses and offers year-round play because of the mild climate. Boca Raton itself has fifteen top golf courses in the area.